Shojo Fashion Manga Art School Year 2

Draw Modern Looks

Irene Flores and Krisanne McSpadden

IMPACT
CINCINNATI, OHIO
www.impact-books.com

Table of contents

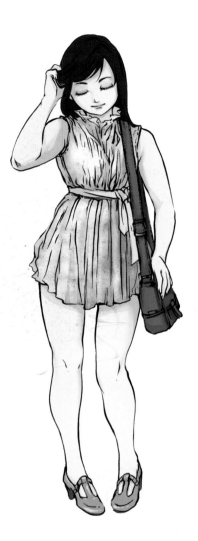
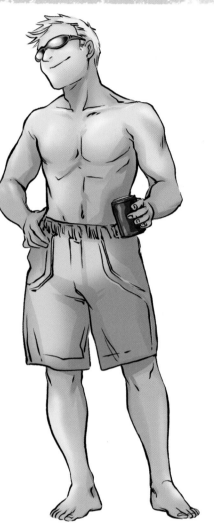
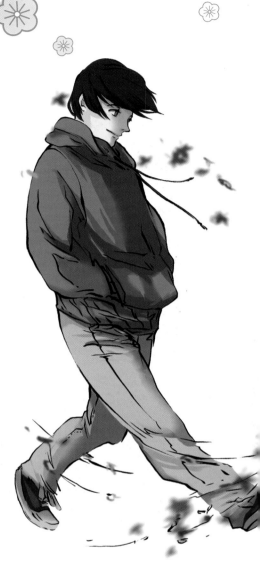

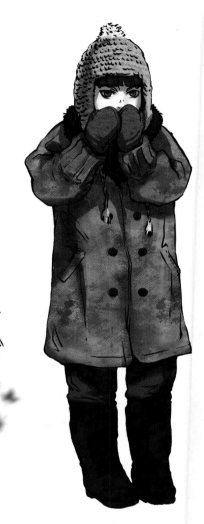

Shopping List

Surface
Deleter Plain B comic book paper
patterned papers for backgrounds

Pencils
mechanical pencils
regular mechanical pencil lead
blue mechanical pencil lead
drawing pencils

Pens + Markers
gel pens
felt-tip pens
brush pens

Tools
ruler
eraser
French curve
drafting templates

Miscellaneous
scanner
Adobe® Photoshop®
sketchbook

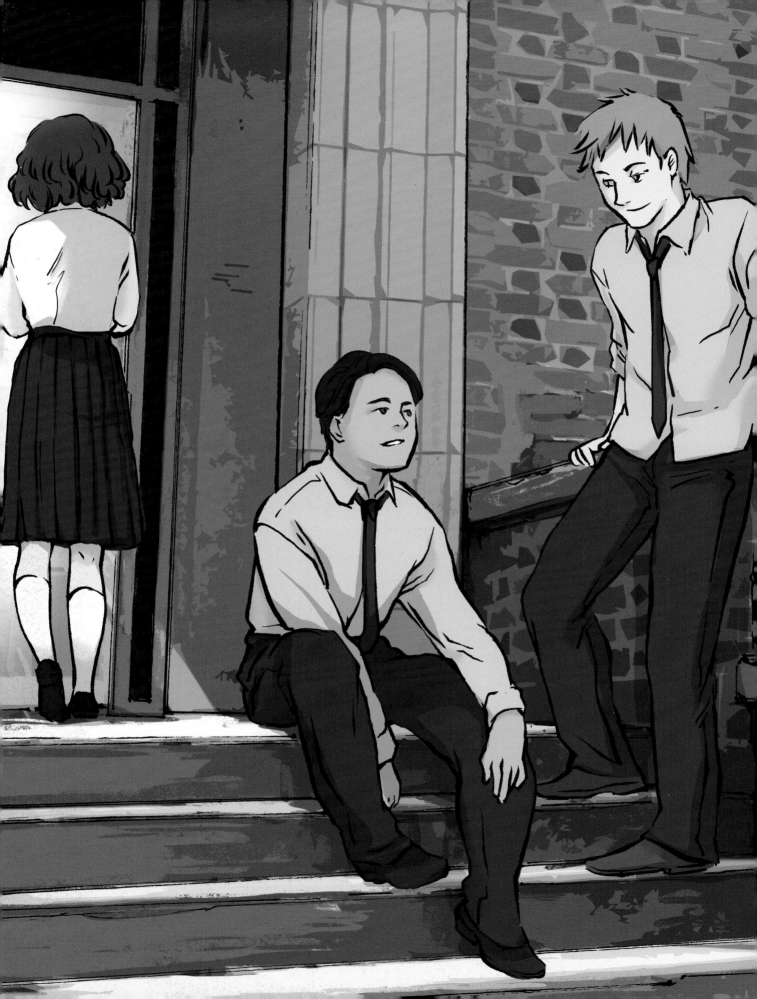

Introduction

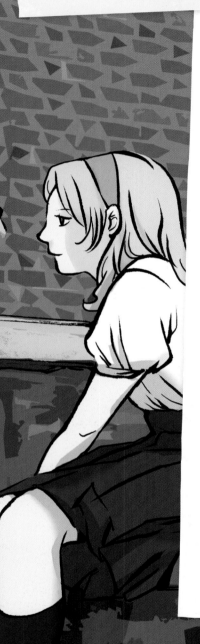

When creating *Shojo Fashion Manga Art School Year 1*—that is to say, the first book!—we hit upon something that we felt was underrepresented, not only in the world of art guides, but manga and comic art in general. Clothing. We found it difficult to find manga or comic books with colorful, unique, creative, realistic clothing. Clothes that change every day, because most characters have more than one outfit. Clothes that get ripped or dirty in realistic ways. Clothes that say something about a character's personality.

For *Year 2*, we've created a manga-style how-to-draw book centered entirely around clothes. In the following pages you will find information on casual clothing, clothing for going out, work clothes, school clothes and even how to design your own school uniform. From prom to weddings, and sports to seasonal, we have covered the basics for manga in a modern-day setting. You'll find tips on every step of the process and hundreds of pieces of art to use for your own reference.

While this book is by no means exhaustive—how could it be? It would take thousand of pages!—we have done our best to create something worthy of a spot on your shelf. And with any luck, this expedition into the world of clothing in manga/comic mediums will continue in *Year 3*.

Pens, Pencils and Paper

All you really need for drawing is a pen and paper, so don't get overwhelmed by the huge market of available art supplies. Here are a few tools I prefer to draw with. Experiment and see what you prefer, or what you can afford.

blue lead

GEL AND FELT-TIP PENS
Use gel pens and felt-tip pens for straight lines and to fill in large areas. Trying to make lines with a brush pen and ruler can be messy and difficult.

MECHANICAL PENCILS
Mechanical pencils are great because you don't have to bother with sharpening them. I always keep one of my pencils filled with blue lead. This makes it easier to go over sketches with darker graphite or ink. Also, blue lead tends to disappear when scanned, leaving the darker pencil or ink lines without having to erase all of the preliminary sketching.

SCANNING YOUR SKETCHES
Sketch a drawing with blue pencil or ink, then lay in your preliminary inks. When you scan the image using the black-and-white setting, the blue sketch lines disappear.

BRUSH PEN
My preferred pen is a brush pen, which gives me varying line weight without having to go over the same spot numerous times.

DRAWING PAPER
I like using Deleter Plain B comic book paper because my brush pens don't bleed as much and ink dries very fast. The dimensions vary slightly from standard U.S.-sized paper, but it still fits my scanner.

Other surfaces such as printer paper, bristol or posterboard will also work as long as they hold lead and ink. Use what you like and what works best with your drawing tools.

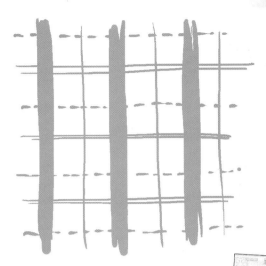

Patterns

You don't need fancy, expensive paper to draw. Whether it's printer paper, thick bristol paper or posterboard, if it will hold lead and ink, it is good. However, some paper will work better with the tools you prefer than others. Experiment and see what you prefer, or what you can afford.

▲ MONOTONE PLAID

When drawing a plaid in monotone, convey the idea of different colors by varying the types of lines used. (In this case, two narrow lines, one thick line, one thin line and one thin dotted line.)

READY-MADE PATTERNS ▶

Ready-made patterns (usually black and white) can save you time drawing patterns and textures for clothing, buildings and backgrounds. However, it's difficult to make the patterns move with the natural folds of a garment when applied to clothing. That's something to think about when deciding whether or not to create your own patterns.

▲ SCAN BACKGROUNDS FROM PATTERNED PAPER

Scan scrapbook or origami paper to digitally create unique backgrounds. Or re-create the patterns by hand.

CREATE A MONOTONE PLAID PATTERN

 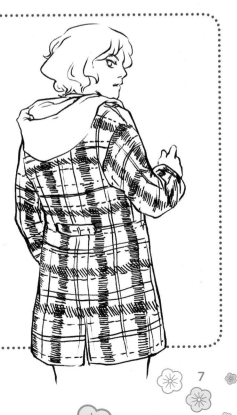

1 Use thick hatched lines and double narrow lines.

2 Criss-cross a second set of double narrow lines.

3 Add dotted lines and thin hatched lines in every other grid.

4 Make sure the pattern properly wraps around the body to move with the shape of the garment.

Draping Fabric

Everyone knows fabrics flutter in the wind on a blustery day. But it can be easy to forget that fabric is lying over a body, and is often changing to reflect the form and movement of the body underneath. Make sure to account for this in your drawing to provide clarity and emphasis of movement.

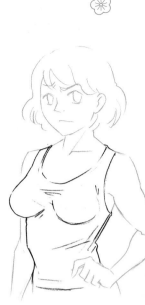

SNUG FEMALE TOPS
Fabric does not magically gather under or between breasts. If a woman is wearing a snug fitting top, just a couple of stretch lines between and under the breasts will do. With more tailored fitted clothing, there won't even be that.

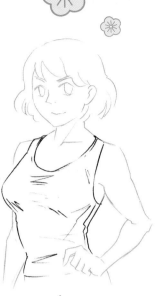

do *don't*

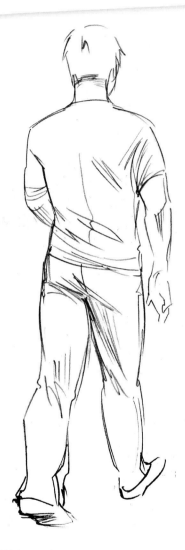

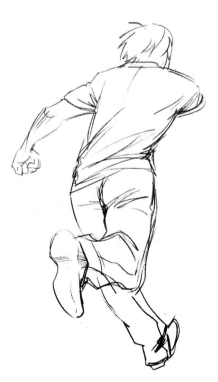

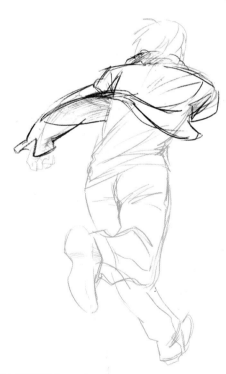

WALKING
When making shallow motions such as walking, fabric movement is less dramatic. Direct the fabric in the proper direction, such as where the lines on the thigh convey which leg is pulling forward.

RUNNING
The body motion of a figure running dramatically engages both the arms and legs. When running, the pants have sharp horizontal folds where the fabric is bent to accommodate the body. The shirt pulls up in the direction of the shoulder that swings forward. The hemline lifts forward in the same direction in response to the arm moving.

BLOWING JACKET
Clingy T-shirt material won't move in the wind much. But if wearing a jacket, the hemline lifts just below the arms and gives the runner a stronger sense of speed.

TECHNIQUE
COLORING

Coloring styles and techniques vary, depending on the medium, the art style and you! This is a brief overview of my coloring process; try out different coloring methods and see what works for you. Don't be afraid to use another artist's style, but learn how to incorporate the style into your own art, not copy another's.

1 Start with some clean, inked art.

2 Flatly color the entire image. Don't worry about highlights or shading yet.

3 Next add shading. I prefer to use one color to go over the entire image, so that the shadow color stays the same and helps unify the picture. Using a pure gray shadow would desaturate the picture and make it look lifeless and bland, so I use darker tones of a color; in this case I used a dark, grayish teal.

4 Add the detail. The pattern on the shirt and the blue glow coming from the phone are done with a bright blue and a bit of white. Otherwise, I don't add highlights. If it were a particularly bright day, or if his hair were shiny, I might use highlights to emphasize that. But since it's an ordinary day and he isn't a supermodel, the layers of shadow create the illusion of highlights without making the picture too complex.

Know Your Characters

There is a tendency in manga to create every character young, fit and beautiful, so try to represent a wider spectrum of characters to appeal more to your audience. Consider how much your characters exercise and eat, and how genetics affect their appearance. How do they dress to represent themselves to the world? Don't be afraid to include characters of different ages and shapes in your manga.

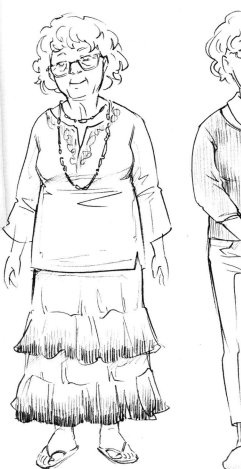

MATCHING CLOTHES AND PERSONALITY

How you dress your characters accentuates their personalities. Putting the same woman in different outfits gives you a vastly different assumption of who she really is.

CLOTHING ON DIFFERENT BODY TYPES

Bodies don't come in only one shape. People develop muscle differently and put on weight in different areas. Here are the basic outlines of chubby, skinny and muscular male body types. Consider what sort of body type you are dressing, as it will affect the way the fabric lies.

DRAWING FASHION OVER FORMS

A lot of clothing design comes from understanding how to place simple forms on the body and then embellishing them to fit your character. Let's make an example of this basic dress shape.

1 Place the simple clothing forms on the body. Here a short slip can be altered into two entirely different dresses.

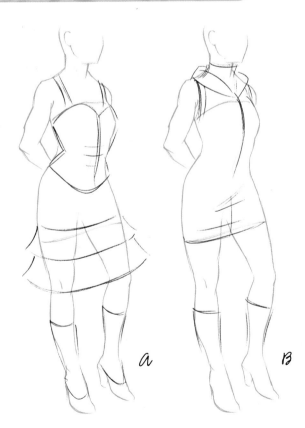

a B

2 Embellish the basic shape to your liking. On Dress A, we've created a long ruffled, layered skirt. The waist pulls in sharply thanks to a corset. On Dress B, the dress stays short, stretching higher up the chest into a hooded top.

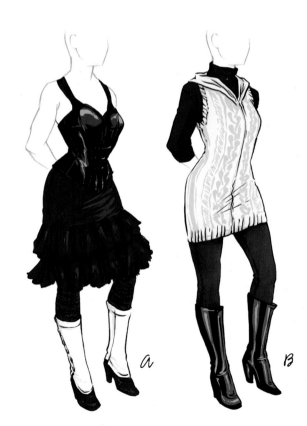

a B

3 Completed and colored, you can see the simplest dress form fleshed out into entirely different directions.

Age Progression

Age definition can be difficult for many artists. It's not uncommon to see wrinkles added to the face of an otherwise young body to represent someone older, or teenagers who look exactly the same as characters in their twenties. This chart shows the typical transformations of the body through the years.

CHILDREN

At age four or five, kids are waist high to most adults, at about the three-foot mark (91cm). Limbs and faces are still very chubby, and there isn't much to define one gender from the other besides hair and clothing choice. Children's bodies appear proportionally squat; their legs won't lend height until later years. The shoulders are also still quite narrow, which makes their heads appear too large.

PUBERTY

Puberty tends to hit between ages ten and twelve. Girls begin showing more dramatic physical changes earlier, and breasts begin to form and hips may widen slightly. They also hit their growth spurt earlier, and for a few years it's not unusual to see many girls taller than boys. Both genders will hit the "gangly" stage, where they are much taller but lack much muscle definition in their limbs. Faces tend to still have some baby fat.

TEENS

By mid-teens, boys and girls are well on their way to their maximum height. Both widen at the shoulders and hips, but girls more in the hips and boys more in the shoulders. Girls' breasts will be larger. Both boys and girls are getting more definition to their limbs, but they are still not exactly shapely.

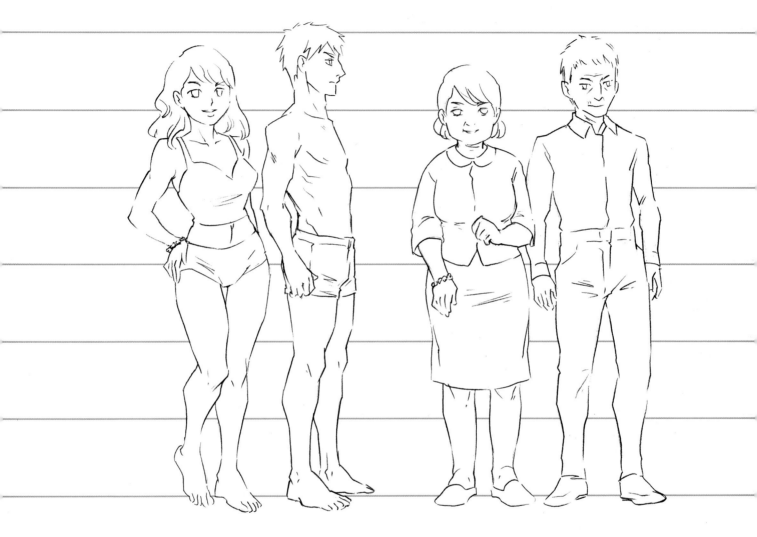

YOUNG ADULTS

Now we finally have a woman and a man.
The last vestiges of baby fat are out of the
faces, both are as tall and as wide in the
hips and shoulders as they are going to
get. Men have a slighter dip at the waist
and a flatter behind than women.

SENIORS

As people age, skin begins to sag and everything moves down-
ward, resulting in less definition of the body. Bones also become
more brittle, and muscle mass disappears, resulting in a thinner,
more frail appearance. In the later years, people tend to shrink a bit,
leaving them an inch or two (3 to 5cm) shorter than they once were.

1 | Around the Home

Anyone who has ever spent all day in socks and a T-shirt knows that around the home, fashion is about comfort and freedom. To some people, freedom may mean sweatpants and tank tops, while to others it can be a polo and a comfortable pair of slacks. It's safe to say it probably isn't going to be a work uniform or an evening gown, and even the most proper businessman looks forward to loosening his tie and kicking off his shoes.

How will your characters dress when there is no one to impress? If their family is on the prim and proper side, there may be no escaping spending every minute of the day looking as if guests might arrive at any moment. But most are going to reach into their closet and grab whatever washes easily, fits well enough, and will be just appropriate enough that other people sharing the house—family or room-mates—won't complain.

Collars

Collars are present on dress shirts and polos. They can be very nice, as on a pressed suit, or more casual. For casual wear, polos are usually just a step or two above tank tops.

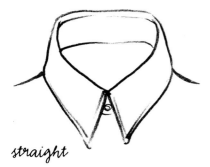

straight

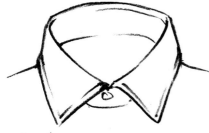

spread

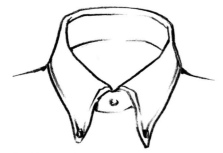

button-down

OPEN COLLARS
Most people leave the collar unbuttoned, particularly when relaxing at home.

DRAW A COLLAR

1 ENVISION THE FULL COLLAR
If fully extended, the collar on a shirt reaches up to the chin.

2 FOLD IT IN HALF
Then it is folded neatly, leaving it at about half the original height.

Sleeves

Here are some examples of sleeve varieties. Most of these sleeves you're going to see on women's clothes, but feel free to get creative. You don't have to stick to gender norms when creating clothes for your characters.

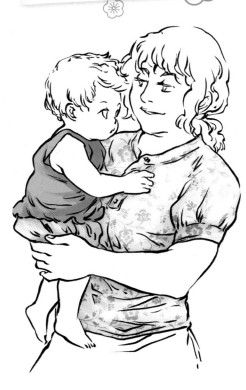

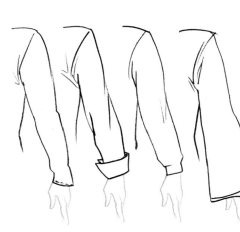

seam

DON'T FORGET THE SEAM
Make sure that you finish the sleeve by adding a seam line where it ends. It doesn't have to be solid; in fact, it shouldn't be! The hint of a line there is a small detail that adds to a more presentable look.

SLEEVE TYPES

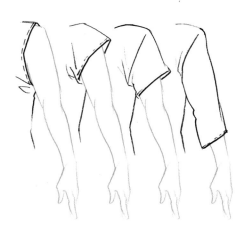

sleeveless, cap, short, three-quarter

long sleeve, french cuff, cuff, angel

butterfly, puff

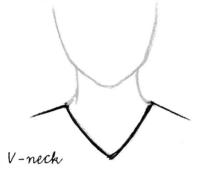

V-neck

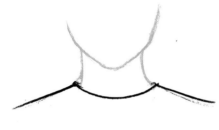

Jewel

Feminine Necklines

While men's clothing usually has a collar or a T-shirt neckline, women's clothing has a wide range of necklines. These names refer to the shape of the cut around the neck. The placement of the neckline—closer to the neck or lower on the chest—is up to you.

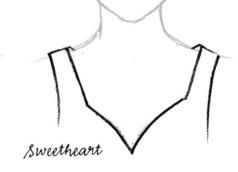

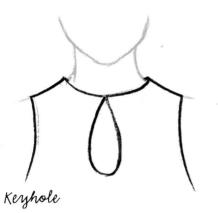

Keyhole

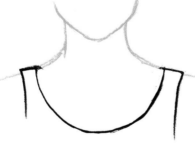

Scoop

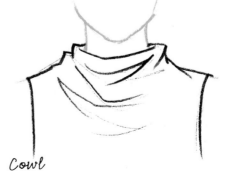

Sweetheart

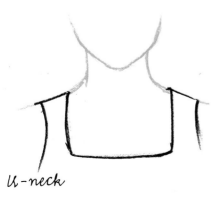

U-neck

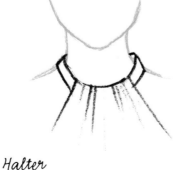

Halter

Cowl

Tykes and Tots

Children's clothing tends to resemble miniature versions of older looks, with an emphasis on durability and bright colors. For children too small to dress themselves, onesies and dresses are a popular way to navigate the hurdles created by diapers and unwilling toddlers.

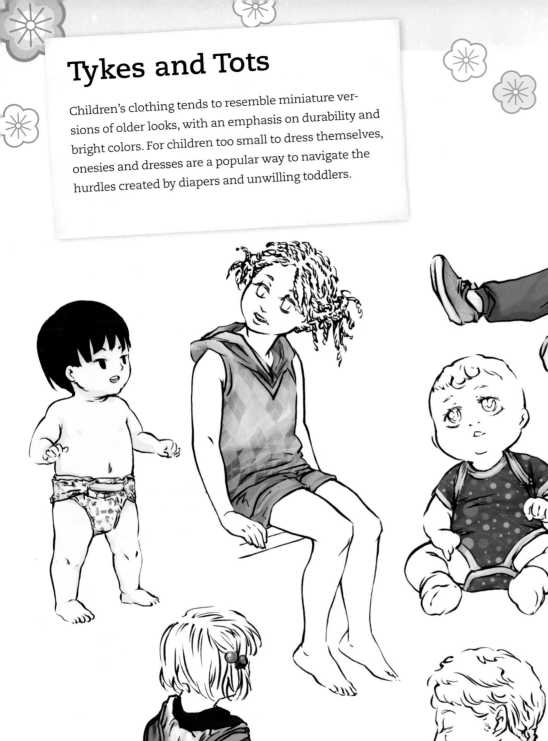

Baby Shoes

Kids' and baby shoes are basically adult slip-ons with smaller proportions and a squashed look.

DRAW ITTY-BITTY BABY BOOTIES

1 **SKETCH THE FOOT**
Babies have small feet and pudgy legs, so make sure you keep the length of the foot shorter than you would on an adult.

2 **OUTLINE THE SHOE SHAPE**
Draw a ballet slipper shape around the foot.

3 **ROUGH IN THE DETAILS**
Embellish the shoe with details—straps, bows and cool designs. Slippers will remain below the ankle while sneakers go up to or over the ankle. Sneakers will also have a thicker, more structured build. You can embellish the shoe however you want with bows, straps or designs.

4 **CLEAN UP THE DRAWING**
Add the socks, lacing and stitch marks. Don't forget the texture that will convey the feel of the material. Baby shoe styles mirror adult shoe styles, but with squished proportions. Approach them with as much creativity as you would regular shoes.

Maternity Clothes

When women are heavily pregnant, their pants button under the belly and the hem will be shoved down. If a woman wants to look a little less pregnant than she is, a tailored dress shirt will flatten out her figure.

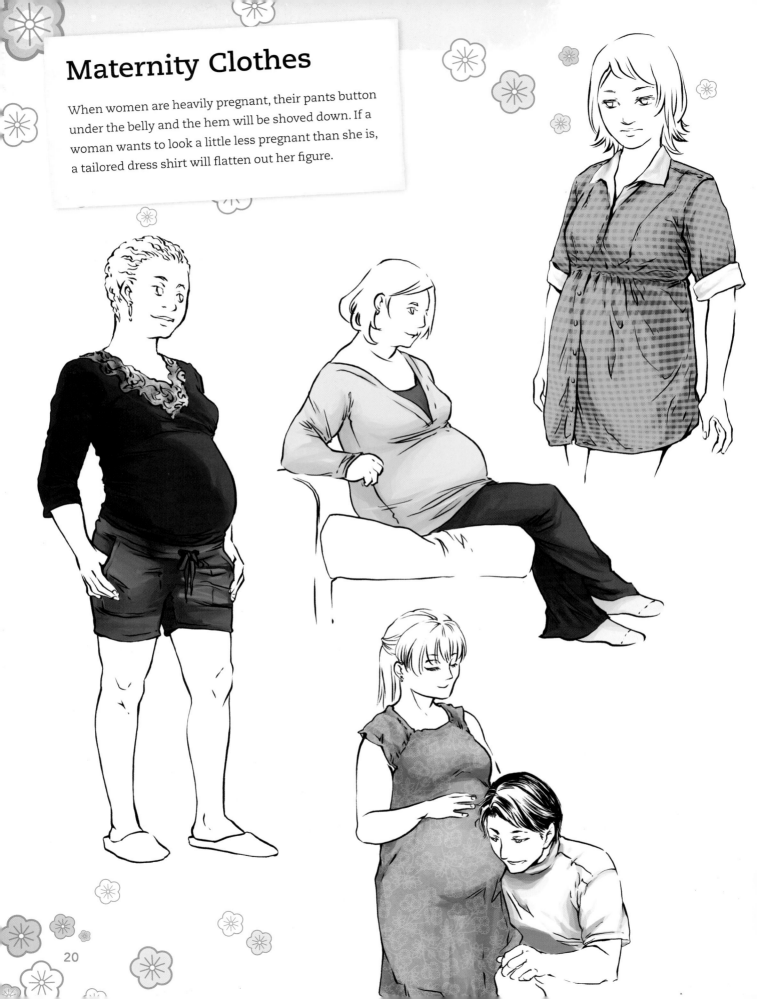

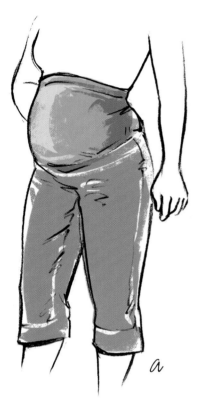

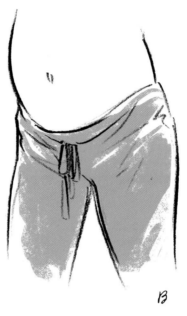

ELASTIC BAND VS. DRAWSTRING

Some pants (A) will have a special maternity band sewn in. They keep the pants up and add support to the belly. Wearing regular old pants, without the support, looks more like Drawing B.

DRAW A PREGNANT LADY

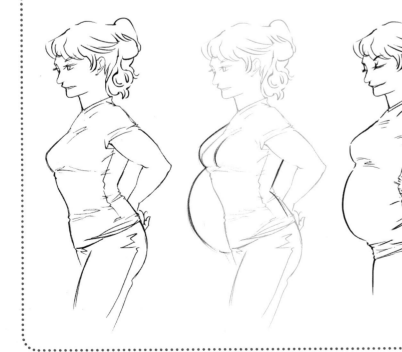

1 Start with a not-pregnant lady.

2 Sketch the belly and slightly enlarge the breasts. How large the stomach is depends on how far along in the pregnancy the woman is, and changes can vary from woman to woman. Some may put on weight everywhere, others only in certain areas.

3 Clingy fabric will be taut over the belly, but gather under it, as well as under the breasts.

University Wear

Show school spirit while doing absolutely nothing! High schools and especially colleges and universities tend to have lots of apparel with the school name, colors and mascot on them, from jackets and T-shirts to pajamas, dresses and accessories.

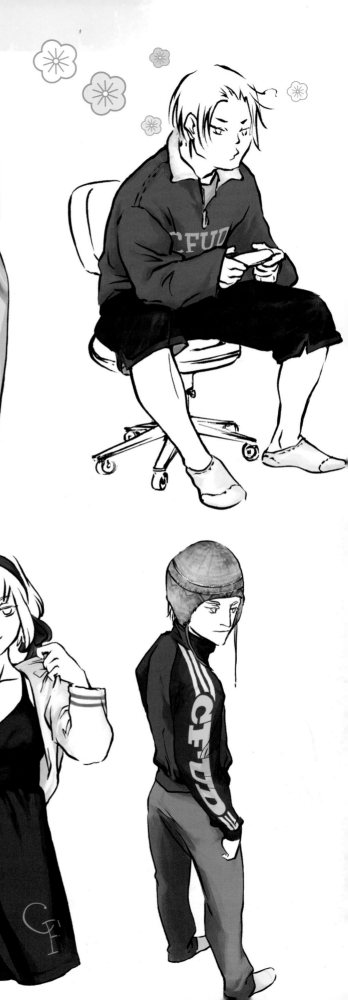

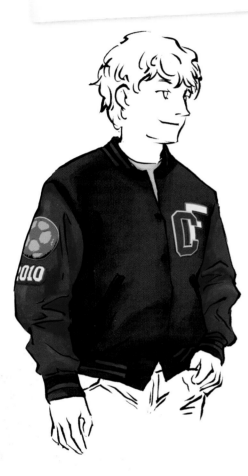

COMPLEMENT THE SCHOOL COLORS

University wear comes in plenty of colors, but especially the school colors. Make sure you choose two colors that will contrast against each other well enough to be easily recognizable.

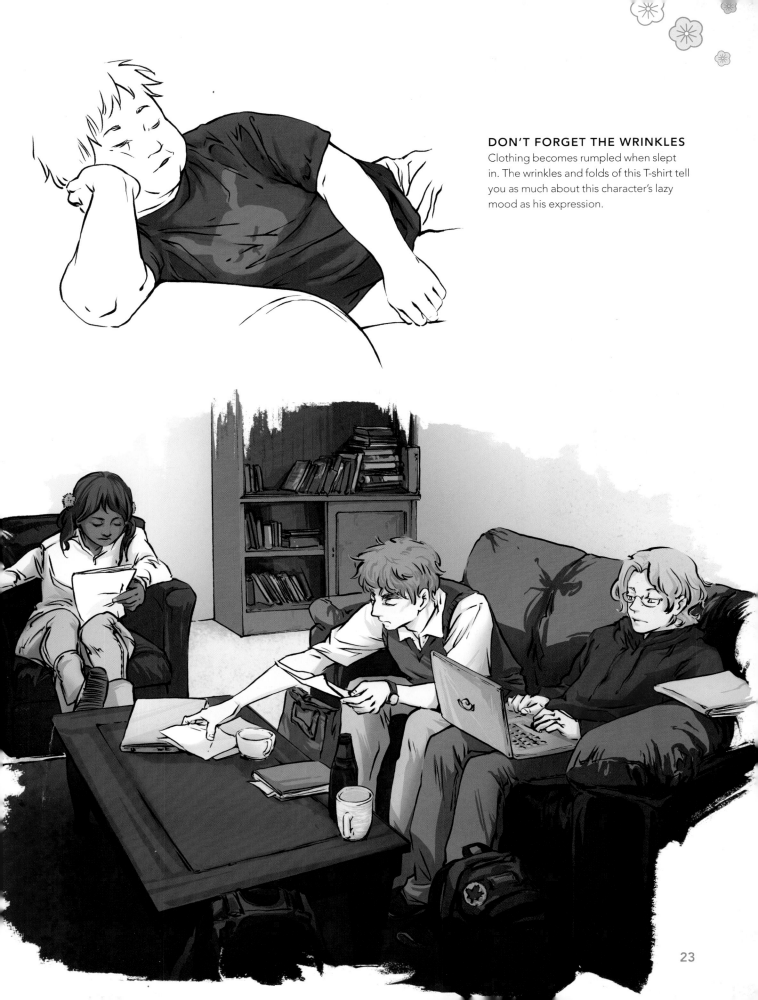

DON'T FORGET THE WRINKLES

Clothing becomes rumpled when slept in. The wrinkles and folds of this T-shirt tell you as much about this character's lazy mood as his expression.

RELAXED POSES

People are more likely to strike interesting poses when they are relaxing by themselves. The unique angles and bends of the body can sometimes mean more work for you, but have fun with it. Mastering complex poses and angles is a big part of becoming a better artist.

CREATING INTERESTING POSES

Poses can still be interesting even if people are just lying around. Aside from straight and profile views, play the angles of the body to create unique poses.

DRAW A LAZY POSE

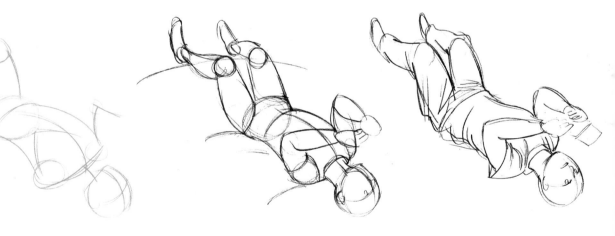

1 Make a rough sketch of the pose, and don't treat it stiffly: the body doesn't just move at the joints. Here the torso is curving down, since his head will be hanging off the couch.

2 Fill out the shapes of the body. If you get a bit confused, try turning the paper around; it's almost a sitting pose that way.

3 Figure out how the pose affects the clothes. There will still be some bunching around the thighs and hips, but thanks to gravity and the shape of the couch, it's all sitting around the waist. The shirt also bunches up where it meets with the couch.

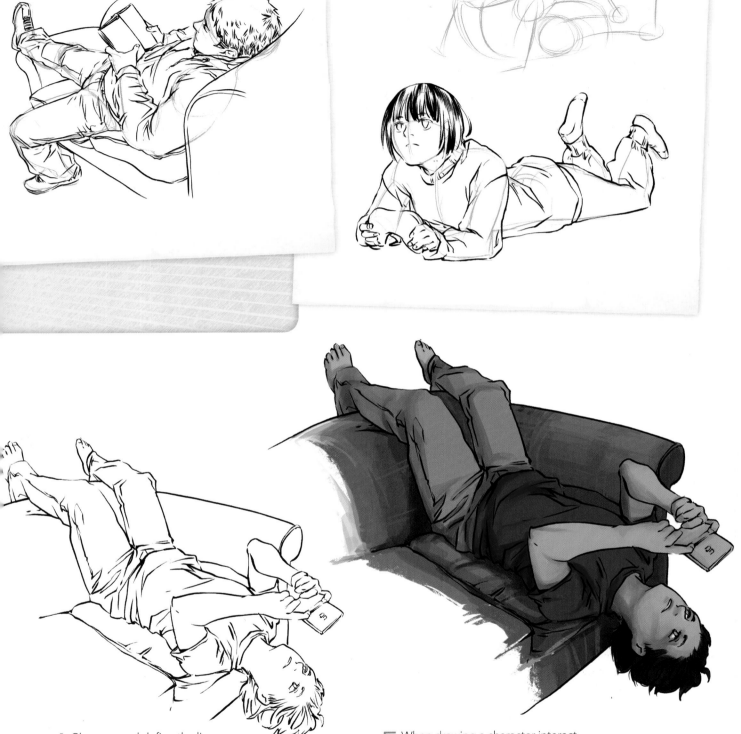

4 Clean up and define the lines, preparing your character for color.

5 When drawing a character interacting with an object, make sure the body casts shadows. Here, the couch cushion the kid is lying on is darker where the body blocks out the light.

Tank Tops

Tanks are basically shirts minus the sleeves, but they come in a few different designs. The material is usually stretchy, so smaller sizes will cling to the body with horizontal wrinkles, and larger ones will hang loosely.

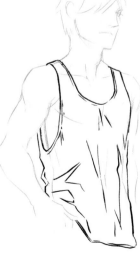

STANDARD VS. Y-BACK TANKS

Women's tanks are essentially the same as men's but cut to make more room in the chest. Draw a Y-backed tank top to show off the shoulder blades.

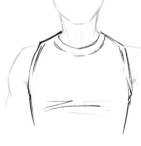

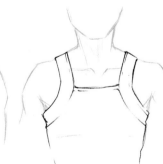

Standard tank

Loose jersey

Sleeveless tee

Square-cut tank

Clothes for Chores

Old frayed clothing is perfect for cleaning up the house. If there is anything nice about household chores, it's that you don't have to look fancy for it.

DRAW A FRAYED SLEEVE

1 A finished hem will have a clean line; add the stitch line for detail.

2 For a frayed hem, add short, uneven squiggles to represent frayed threads.

DRAW RIPPED JEANS

1 To make a pair of jeans old and ripped, add a series of lines for wear and tear in the threading. The lines don't have to be perfectly parallel, as some of the thread has been stretched or cut and will dip or hang.

2 For a frayed hem, add some jagged squiggles. This is also good for the edges of holes in the jeans.

3 Fraying is going to happen wherever the fabric is stretched or rubbed the most, so generally on the knees and the thighs.

Yard Work

Yard work is best done in old worn-out clothes and heavy-duty shoes. Garden accessories like gloves and hats are common as well. Fashion is usually not a consideration.

HATS

Sun hats have wide brims to shade the face and are usually a lighter color to help reflect sunlight. Beyond that you can style or pattern them just about however you like.

GLOVES

Work gloves tend to be ill-fitting and make hands look bulkier than they are. Use thick lines to represent the deep folds in the heavy fabric.

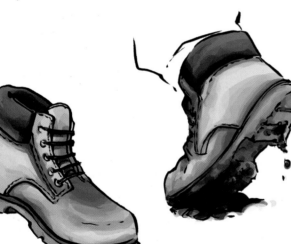

BOOTS AND SHOES

Work boots have a thick sole with a heavy tread to lend better traction. And of course they'll get dirty—maybe even caked in mud.

DRAWING DIRT ON CLOTHES

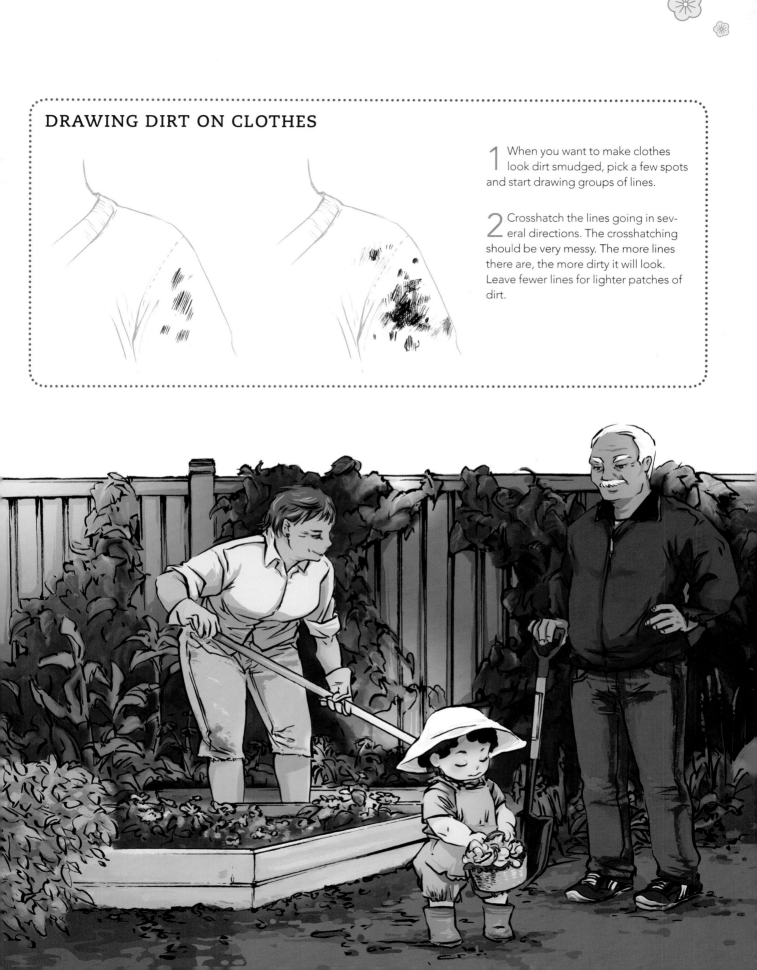

1 When you want to make clothes look dirt smudged, pick a few spots and start drawing groups of lines.

2 Crosshatch the lines going in several directions. The crosshatching should be very messy. The more lines there are, the more dirty it will look. Leave fewer lines for lighter patches of dirt.

Adult Sleepwear

Sleepwear options are unlimited. They usually mimic the same forms and designs found in daywear. Anything from underwear to nightgowns to flannel pants to oversized T-shirts are a go, so think about what your character's at-home casual wear is like, and what matching sleepwear would be.

Kid Pajamas

Kids' clothes can look like just about anything, because the kids don't usually have any say in how they're dressed. And how many parents can resist putting their child into a polar bear onesie?

2 | Hanging Out

When your characters are out and about on the street, at school or at the store, they will be judged by their appearance. People make assumptions about them based on how they are dressed. It is a painful truth that we are all aware of, and most people deal with it by dressing in a way that represents who they are. This could mean dry-clean-only clothes, heavy accessorizing, or even staunchily refusing to change out of the T-shirt and sweatpants that were good enough for the living room. Whatever it ends up being, it ultimately is going to send a message to the other characters of your world, and to the readers of your story, so consider what your character has to say.

Jeans

Most people have a favored style of jeans, and won't be comfortable in much else. Although the differences may seem subtle, men and women alike will notice the difference between someone in a straight cut or a skinny, so think about it when you dress your characters.

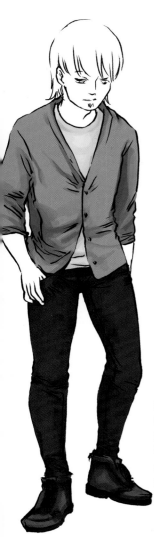
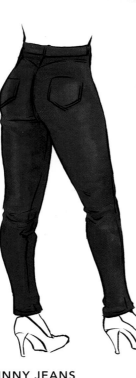

SKINNY JEANS

Skinny jeans tend to be a rather snug fit. They can be shorter than other jeans because going down over the shoe isn't an option. You can also cuff the jean if it's too long.

LOW VS. HIGH WAIST

Low-waist jeans sit just over the hip bone. High-waist jeans go over the belly-button and will usually have a much smaller waistline in order to keep them from sliding down; predominantly a girl's jeans.

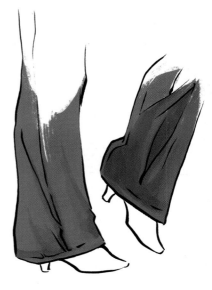

SKINNY

These have a tight fit over the butt and legs. Definitely a sexy style.

FLARE

Narrower legs that flare out starting at the calf. Generally a more youthful cut.

STRAIGHT

Straight cut have the same width all the way from the thighs down to the ankles. They are both casual and comfortable.

BOOTCUT

Narrows slightly on the leg and has a wider ankle to fit over a boot.

WIDE-LEGGED OVER THE SHOE

A stylish look for wider-legged jeans and pants is to be worn much longer so the shoe is almost hidden. This works great with heels and boots.

Women's Shoes

Women tend to have a preference for footwear, and when on a casual outing are going to wear what they find most comfortable. Heels and laces tend to have a more refined look to them while straps, Velcro and buckles have a youthful appeal. Slip-ons are many people's go-to shoe for a casual outing. They can look professional or plain, and are a good choice if your character is expecting to be out all day.

Ruched Fabric

A ruche is a gathering, pleating or ruffling fabric. It is similar to the effect you might get from tying a sleeve closed with a string. However, instead of a string, it is the stitching of the fabric, and instead of closing the sleeve, it merely tightens it in bands so that an attractive wrinkling occurs.

RUCHE FABRIC FOR A FUN AND STYLISH EFFECT
You can ruche fabric just about anywhere: sleeves, waists, necks or even the entire shirt.

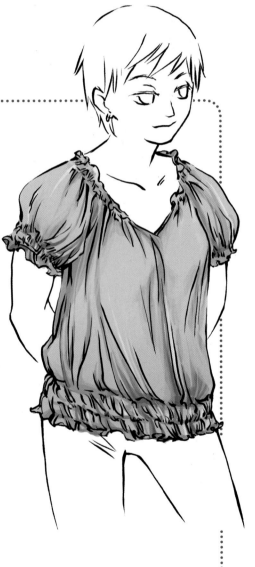

DRAW A RUCHED SLEEVE

1 Start with a simple, loose fabric sleeve.

2 Draw guidelines where the fabric will tighten and gather, shortening the sleeve.

3 Within the spaces between the guides, sketch many small wrinkle lines. Be sure not to make them too uniform. Make the wrinkles longer the further away they are from the stitching.

4 Clean up the drawing and erase your guidelines. The illusion of the stitch lines is in the negative space between the wrinkles.

Men's Hats

Leaving the house doesn't always mean changing clothes, especially if you're just out to take a walk in the park. But accessorizing with a hat is a nice way to add some interest, prepare for a blustery day, or just hide a bad case of bedhead.

LIKE FATHER LIKE SON

Before children are old enough to dress themselves, they are subject to their parents' sense of fashion.

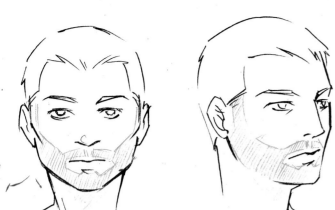

Facial Hair

Facial hair growth varies by race and age, and from man to man. Many, for example, can only manage a patchy beard, while others won't have sideburns that reach all the way up to the hairline.

TYPICAL BEARD GROWTH

Facial hair only grows on certain areas of the face; the blue shaded areas here represent the standard. Hair also grows along the underside of the chin and down the neck, but this is usually shaved (neck beards are out, trust us).

VARY YOUR STROKES TO VARY THE FACIAL HAIR

Use tiny dashes for stubble; avoid lining them up too neatly. Much like drawing hair on the head, use longer strokes to show more growth. Straight lines, slightly curled lines and very curled lines will create different looks.

Electronic Accessories

There are so many alternative cases, stickers, clips and holders available for phones, laptops and handheld games. Instead of displaying brand names, and boring black or gray equipment, color your accessories in ways that reflect your character's personality.

AVOID BRAND NAMES

It's best to avoid putting brand names on gadgets and accessories, for copyright reasons. Instead, customize your character's portable tech accessories to show off their unique style!

Casual for Coffee

Coffee shops are the modern-day watering hole. All circles of high schoolers, business people, hipsters, old folks, tourists and locals alike drink coffee (or tea, or smoothies), and most enjoy the calm atmosphere and free Internet. They are good places to people-watch if you want to practice some life drawing, and good places to set your characters for a local hangout.

CHARACTERS IN ACTION

Get in the habit of drawing characters gesturing, or with objects in their hands: going through a purse, drumming fingers on a table or drinking coffee.

CHARACTERS
PLUS-SIZE GIRL

Heavier characters are underrepresented in manga, which is too bad, because all characters, regardless of size, can add personality, style and dress to your manga. Other than adding an extra layer to the original structure, drawing and coloring plus-sized characters isn't any different.

1 Start with a basic pose sketch.

2 Rough in the main body shapes.

3 Now add the weight. Women tend to wear their weight spread out, so an hourglass figure will not completely disappear so much as widen and soften. Practice sketching differently sized people to get a feel for proportions. Trust your original structure and anatomical knowledge.

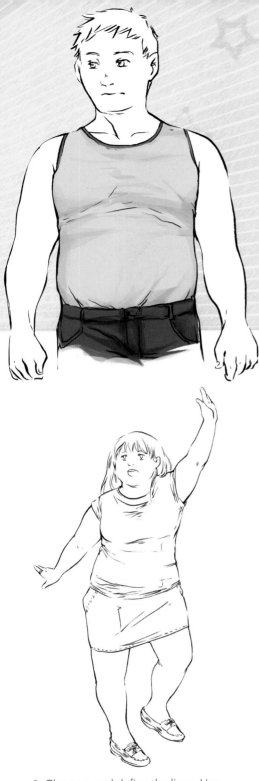

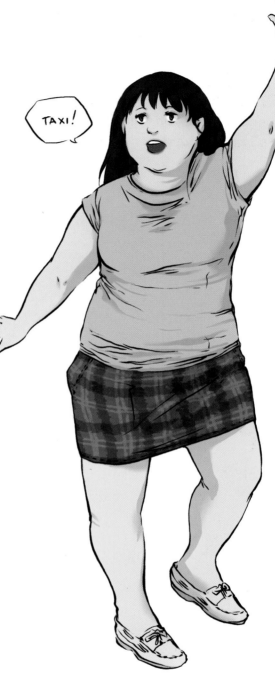

4 Clean up and define the lines. Her clothing is fitted, so it shouldn't have any more wrinkles or stretch than a smaller character.

5 Color your character in a way that reflects her personality and style.

CHARACTERS
FIRST DATE

Manga without any physical interaction is going to be just as boring for you to draw as for others to read. Here are some classic date examples for how to get two figures to believably interact with each other.

1 Super simple stick figures are for getting the rough ideas of height and proportion. The heads are about the same shape, but the figure on the right needs to be a bit shorter.

2 Start sketching the pose. Don't skimp here! Drawing characters interacting is a lot harder than drawing some guy staring off into the distance. Their poses need to be believable. In this case, the figure on the right is leaning on the figure on the left, and unless their bodies are connecting, it won't look right. Also keep in mind that they need to be in proportion to each other, or they will look off. The figure on the right is a small girl; it would look strange if her torso were larger than the boy's, or her hips narrower.

3 Add more detail to the body to get those proportions right, and sketch out the features enough that you can see these two are believably interacting. Their lines of sight should meet up, their heads tilted toward each other. If the pose isn't working, here is the stage to fix it. Don't make the mistake of dislocating your character's arm just so the two of them can hold hands.

4 Rough in the fabric. The girl's clothes are tighter and will have less wrinkles than the boy's hoodie, but her weight on him is going to drag his clothes around a little bit.

5 Coloring should tie the characters together. Make sure their light source is of the same strength, color and direction. They should cast shadows on each other as well, if one of them is blocking the other's light.

CHARACTERS
GOING STEADY

Couples that have been dating awhile usually have more intimate interaction, and thus are harder to draw. When you have a character sitting on another's lap like this, it's very important to get the proportions and weight of the characters right—and even the way the man shifts back to make room for her.

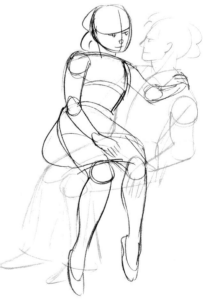

1 Do a couple of rough sketches approaching your pose ideas from different angles. It saves you time in the long run—you don't want to get all the way to inking before realizing you'd like to be able to see the girl's face.

2 Even if a part of the body will be covered, such as the boy's legs, sketch them out so that you know his legs are in proportion to hers. It will also help you better understand the pose you are drawing, since it might not look on paper exactly as you were thinking in your head.

3 Now that the line sketch has determined their proportions, start filling in more detail on the body. Keep drawing through at this stage, so that proportions stay in check.

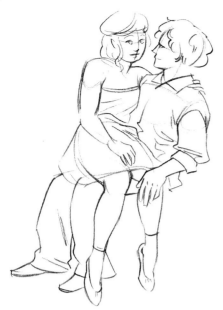

4 This time we have more draped clothing, so this is the time to be sure the fabric is flowing correctly. You can also clean up your lines in preparation for inking.

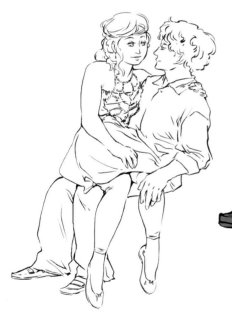

5 Time for inks. You should have solved any problems with the pose in the early steps. Once you add ink, fixing mistakes is a lot harder.

6 Characters aren't usually under only one light source. A single light source may be bright enough to be reflected off every surrounding surface. Essentially, because something isn't in the direct path of the light doesn't mean it is going to be in a dark shadow. They may be in partial lighting, which is why the woman's left side is not as shadowed as the shirt on the man's lower chest, where the light is blocked by both of their bodies.

High School

There are few places to find such a dramatic expression of character through clothing than at a public high school. With so many young, confused, emotional teenagers trying to individualize themselves, it often becomes possible to determine which clique a student fits into just from how they dress. Hobbies, personality and interests can also be inferred. Like all stereotyping, you can subvert these assumptions to create unique characters, or you can bend it to your favor and introduce your characters' hobbies and personality with very little effort.

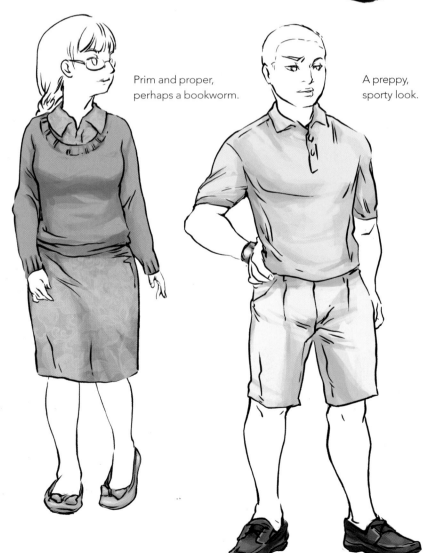

Prim and proper, perhaps a bookworm.

A preppy, sporty look.

Some people just wear what they like—who cares about fashion?

SCHOOL SHOES

You can probably tell which of these shoes are worn by students, and which are worn by teachers. Since school is an all-day affair for most, shoes tend to be comfortable, and many schools have rules that toes must be covered, so sandals are usually out.

She might like anime.

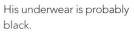
His underwear is probably black.

Backpacks

Backpacks have become an iffy issue over the past few years. Some schools don't allow them at all, or simply try to make them unnecessary. Others require that backpacks be see-through for safety reasons. If you're drawing any kind of school setting, you'll probably find yourself drawing a heck of a lot of backpacks, and with the number of options out there, each one should look a little different.

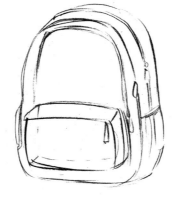

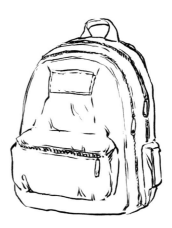

PAY ATTENTION TO THE STRAPS
Make sure the backpack hangs from the straps and isn't free-floating up over the shoulder blades.

DRAW A BACKPACK

1 Backpacks are essentially oblong rectangles or triangles.

2 You can decorate them with as many pockets as you want. Nowadays most have at least two major compartments and some sort of MP3 or cell phone carrier.

3 Snazz it up a little. Backpacks can come with netting, pull cords, colorful zippers, one or two straps, and clear or multicolored pockets. Kids are going to be friends with this piece of equipment for at least a year, so they tend to be pretty choosy about what they get.

Elementary School

Public school settings are great because of the almost unlimited ways the characters (and thus the author) can express themselves. Don't be shy about having a character who can't dress herself, or can't keep his mother from shoving him into a pair of cutesy overalls.

CONFIDENT POSE

High school is all about self-expression, and some people do that a little more loudly than others. A confident pose might involve a wide stance, or grand gestures. Direct eye contact and facing the body toward who the person is speaking with are also signs of confidence.

1 The forward motion of her body, with one hand raised and the other at her hip, and the tilt of her jaw all convey that this girl knows what she is talking about and is here to make sure you do, too.

2 Fill in the body and check your proportions. She is both a little rounder and a little more muscular than average.

3 Start adding definition. Her outfit has a lot of draping involved; you want it to pull in the direction of her stance, which here means upper left to lower right diagonally across her body.

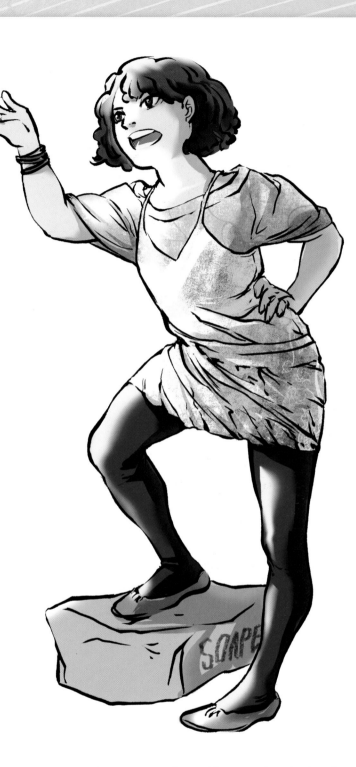

4 Ink the drawing. The skirt has some natural pleats that you don't want to forget in favor of the larger folds created by her raised right leg. Convey the leggings in the linework by making sure you include small folds and wrinkles at her ankles and behind the knee.

5 A confident girl is well suited for an outfit with a lot of bright and bold colors. This character is facing a bright light, so the colors of her clothes wash out to almost white. The purple shadows create a nice contrast that draws attention to her.

CHARACTERS
BAGGY CLOTHING

Ultra baggy clothing is really in style in certain circles. These can be hard to draw because there are a lot more wrinkles in the clothing. And just because the waistline is being worn around the thighs doesn't mean you can make the pants proportionately smaller.

1 This time we're going for a slouched posture: head and neck down a bit, shoulders curving down and inward.

2 Fill in the body proportions and then add the lines of the clothes around them. In this case we're going for a long hoodie that will go down to mid-thigh, so you don't actually see where on the hips the baggy pants are sitting.

3 The clothes are very baggy, so the folds in the fabric are due more to gravity and the stiffness of the fabric than the shape of the person wearing them. Because the butt of the pants is so low, you will have motion wrinkles all the way down around the knees as he walks.

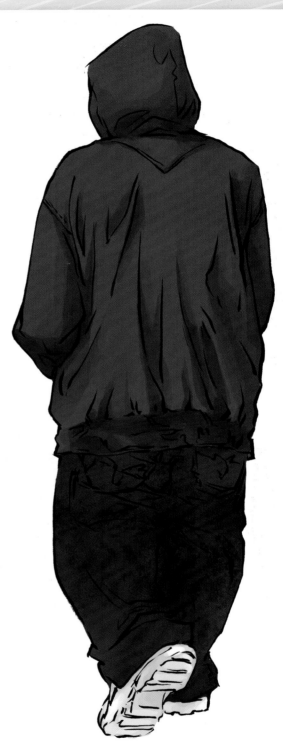

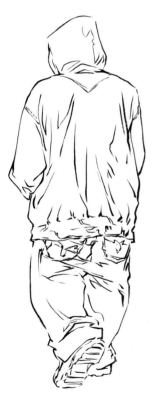

4 Time to ink. Heavy fabric lines, both in the outline and the wrinkles, lend a sense that the fabric is rather heavy, like it's just barely staying on him. Don't use the sloppiness of his style to get sloppy with details. Hemlines, pockets and seams should stay defined.

5 Color the drawing. The waistband of the pants is often worn anywhere from low on the hips to completely below the buttocks. Depending on how low the waistband is, the crotch will also bunch up between the upper inner thigh and the knees. In this case, the waistband is sitting on the upper thighs, and if he weren't wearing this hoodie, you would probably see his boxers.

3 | Prom

For most people, calls to get really gussied up are rare occasions, but they make great events for manga—not only as momentous events, but as a chance to show off how your characters would look if they really put some effort into it! The next two chapters focus on prom and weddings, two major dress-up events that most people are likely to attend. Formal clothes fall at the opposite end of the spectrum of casual dress.

Dresses

The prom dance is a staple in many high school story-lines. Dances are a great chance to show your characters glitzed in their own personal style.

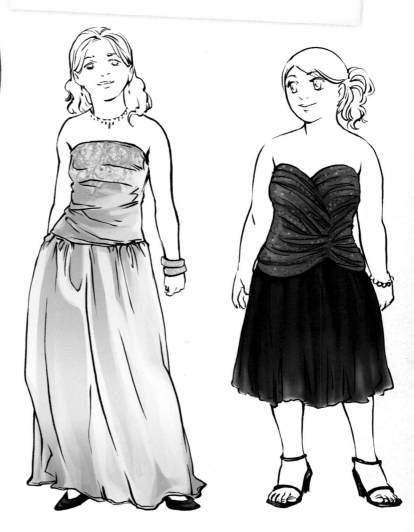

KEY ELEMENTS OF A PROM DRESS

Prom dresses usually share several key features:

1 *Concealed cleavage*

2 *Exposed shoulders and legs*

3 *Saturated colors*

4 *An element of poofiness—layers, draping or pleats that differentiate the dress from a sleek evening gown*

5 *An element of glitz—shiny/glossy fabric such as satin, glass beads, sequins or all of the above*

Beads and Baubles

Beads are an excellent way to add color, patterns and glitz to your prom dresses. They can be used as a general overlay to add sparkle, or be bedazzled on fabric in intricate patterns that completely change the look of the dress.

CLOSE-UP OF BEADS

If you are depicting a close-up of your character's dress or jewelry, here are some examples of decorative stringed beads.

BEAD PATTERNS

Beads and sequins can be placed in patterns, or just spaced evenly around the dress. You can also use them to show the way light plays on the body.

ADD A DECORATIVE BEAD PATTERN

1 To decorate a beaded dress, sketch out the design you want with simple lines.

2 Detail the beads. If you're not doing a close-up, it isn't necessary to draw every bead. Add dots individually and in groups to convey the idea without bogging a dress down in detail work.

Suit Jackets

Men's formal wear isn't as diverse as women's, and a standard for men is the suit. There are a few details to keep in mind to depict a realistic suit jacket. The cuffs and the folds along the back should pull in the direction of the shoulder. The shirt peeks out at the neck and wrist, and varied seams keep the jacket from looking oversimplified and flat.

When the arms move from a relaxed position, the stiffer fabric responds with several deep folds leading from wrist to shoulder.

LAYERING A SUIT

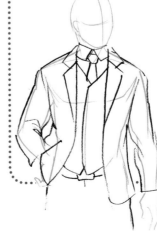

The seam of a jacket goes over the top of the shoulder and below the armpit. It is meant to fit over a shirt and come on and off easily.

Arms don't hang exactly straight. Account for their natural bend when you draw. The wrist of the jacket will be notably larger than a shirt.

1 Most of men's formal wear starts with trousers, a dress shirt and a tie.

2 For a three-piece suit, a vest goes on over the tie.

3 The jacket goes over the vest. For a two-piece ensemble, leave out the vest.

Ties

Ties and bow ties are neck accessories for men's formal wear. The best tie is usually the simplest one. While they are great for adding color to an otherwise boring outfit, overly eye-catching or detailed patterns can look gimmicky. Both regular ties and bow ties come in clip-on form.

BOW TIES

If your character can't tie a bow tie, a clip-on is the likely solution. Here is how a bow tie looks undone.

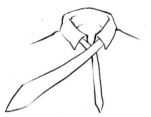

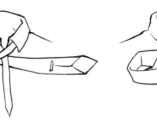

HOW TO TIE A TIE

Tying a tie isn't actually that difficult, if you know the steps. In case you need to draw your character getting ready, here is how it's done.

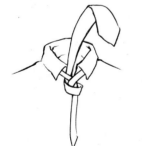

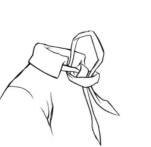

front and back of a tie

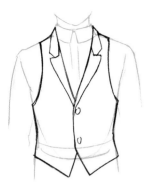

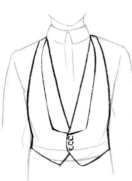

Vests

A vest is an option for men's formal attire. Including a vest under a sport jacket is what makes a three-piece suit. Vests can be worn on their own when a full suit is too formal for an occasion. Vests tend to come in neutral colors to go along with the full suit; however, when designed separately and for a younger crowd, they aren't limited by color or pattern.

DOUBLE-BREASTED VEST
Two rows of buttons just like double breasted jackets.

TUXEDO VEST
Can be worn in place of a cummerbund. Usually low-cut to show the shirt, and can be single- or double-breasted.

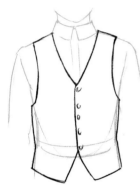

CLASSIC SUIT VEST
Includes four welt pockets, usually made of the same material as the suit.

SHORT WAISTCOAT
The short single-breasted waistcoat exposes the belt and the trousers, along with some of the shirt underneath. It's a younger, casual look.

OPEN OR CINCHED
An unbuttoned vest will droop a bit. To get a tailored look, vests may have a belt or tie along the back.

Suspenders

You better believe that suspenders are sexy. They add interesting lines to the body when men often have a somewhat limited range of dressing up and can take some of the formality out of a look while adding class.

Suspenders don't have to be a boring old neutral. They are a great way to add some color to an outfit.

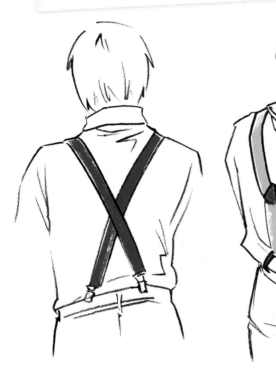

Suspenders attach to the back and front of men's dress pants, usually with clips. They will either make an X or a Y formation in the back, but look the same in the front.

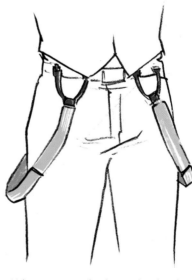

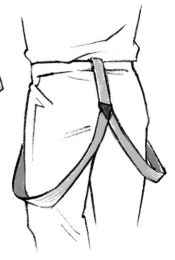

When not stretched over the shoulders, suspenders will hang down to about mid-thigh.

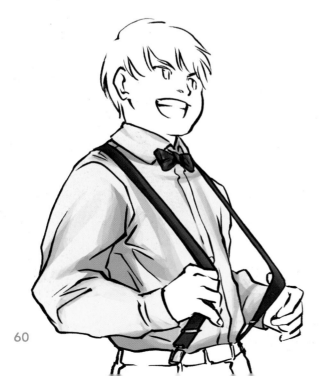

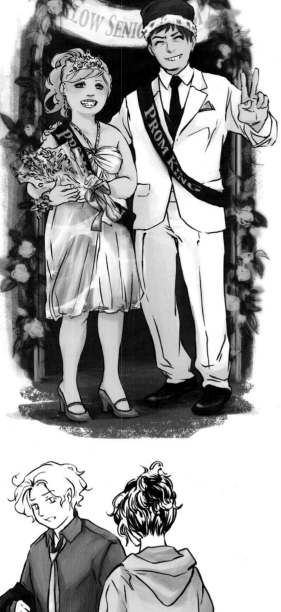

Scenes From the Night

After the dancing and revelry has worn everyone down, that much excitement has an equal amount of down-time to balance it out. As the night comes to a close, dances slow down, the king and queen are crowned, and girls are grateful for the chance to take off those heels.

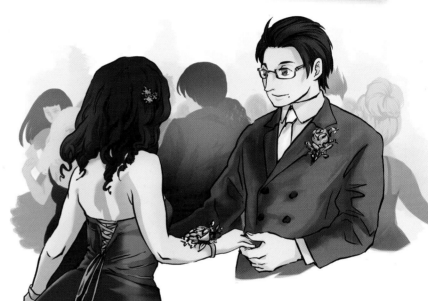

Unique Prom Looks

There's always going to be someone who shows up at the party proud to buck tradition. Familiarize yourself with the styles of formal wear from different eras and cultures.

Duct Tape dress

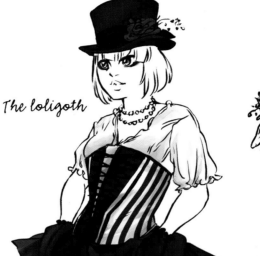

The loligoth

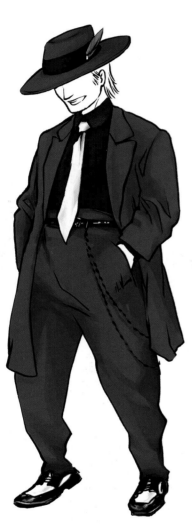

The Zoot suit

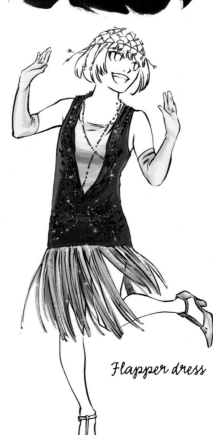

Flapper dress

The outsider

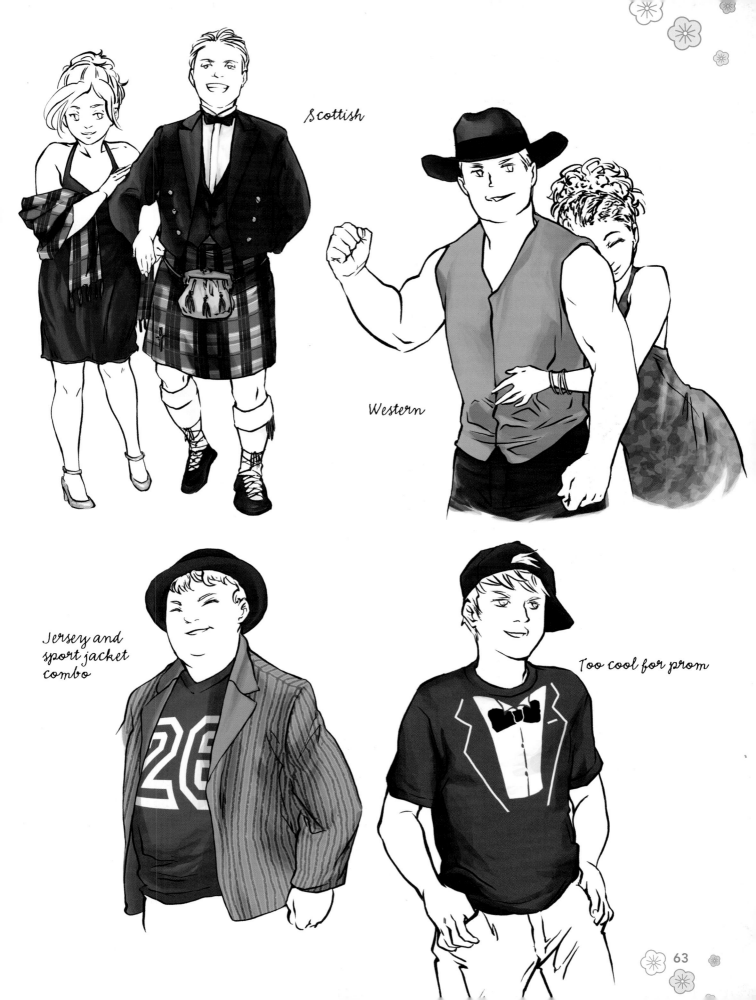

Scottish

Western

Jersey and
sport jacket
combo

Too cool for prom

4 | Weddings

Like prom, weddings are another milestone social event that most people will attend at one time in their lives, whether it is their own or a friend's. They serve as a great opportunity to dress up your characters. In this chapter, we look closely at the structure of different wedding gowns, and how to convey the texture and stiffness of different fabrics. We'll also talk a bit more about formal men's wear, and flashy formal looks for little kids.

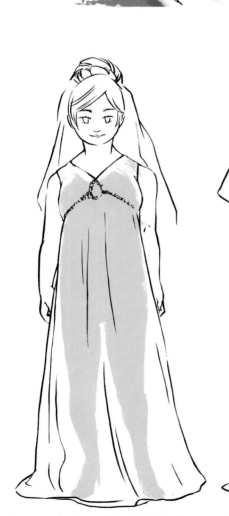

A Tailored Dress

The cut of a dress should emphasize or downplay different parts of the body. A high waistline has less attention on the waist and hips, while a waistline right on the waist draws attention to them. Shorter skirts show off the legs, and trumpet skirts emphasize the hips.

Empire style dress with a high waistline

Trumpet style tapered to the knee then gradually flared

Strapless mermaid style immediately flares at the knee

Wedding Dresses

The main variations of the wedding gown are the neck and shoulder cuts, length and fullness of the skirt and where the waistline is located.

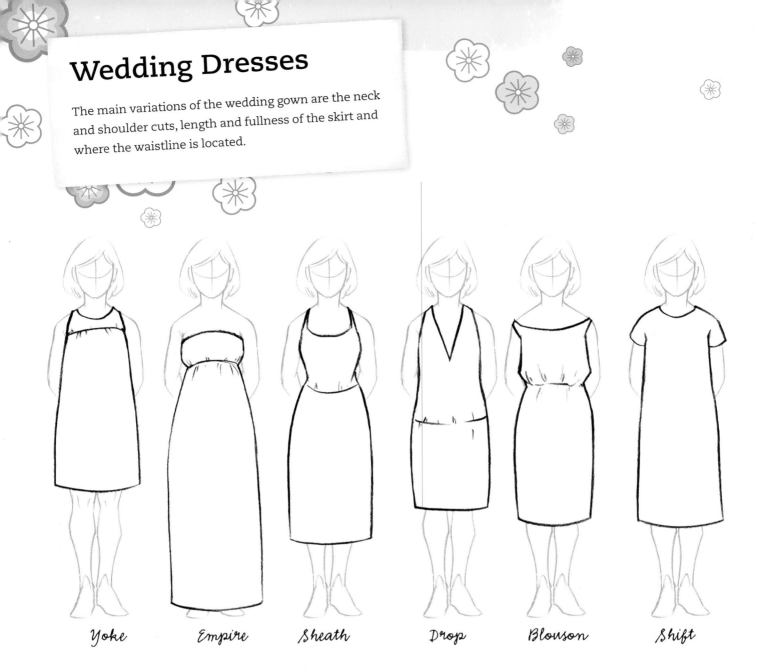

Yoke Empire Sheath Drop Blouson Shift

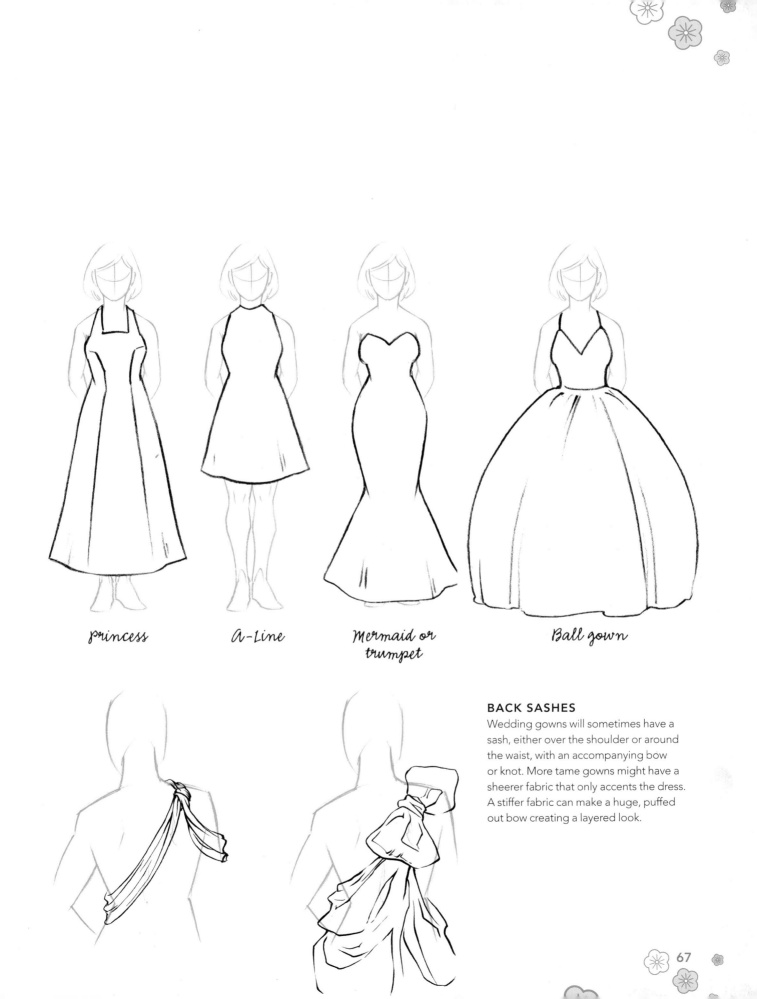

princess

A-Line

Mermaid or trumpet

Ball gown

BACK SASHES

Wedding gowns will sometimes have a sash, either over the shoulder or around the waist, with an accompanying bow or knot. More tame gowns might have a sheerer fabric that only accents the dress. A stiffer fabric can make a huge, puffed out bow creating a layered look.

Dress Fabric

Wedding dresses come in a variety of designs and styles. Fabrics of different texture, opacity and stiffness are used to make sure the bride looks just right as she walks down the aisle. Some fabrics will drape the shape of the body while others are stiffer and meant to hold a unique shape.

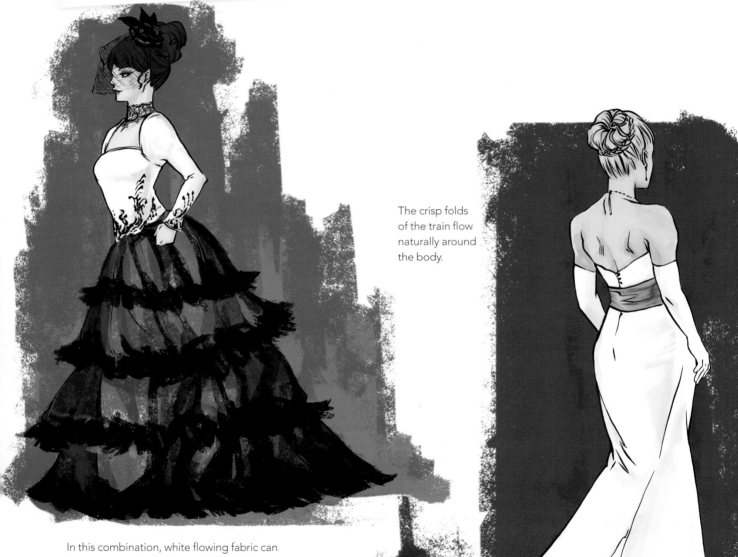

The crisp folds of the train flow naturally around the body.

In this combination, white flowing fabric can be seen through the sheer, stiff black fabric.

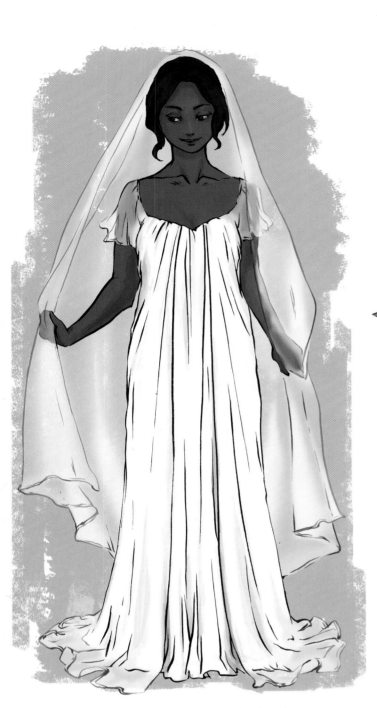

The fabric in these two examples has no body and falls straight down. With loose fabric, pay extra attention to the folds and drapery for an attractive look.

Despite fitting well to the body, this is actually a stiff fabric tailored tightly to fit her body exactly.

Lace

Lace can be a prominent component of many parts of the wedding gown, including the veil, the sheath over the dress, the trim and the gloves.

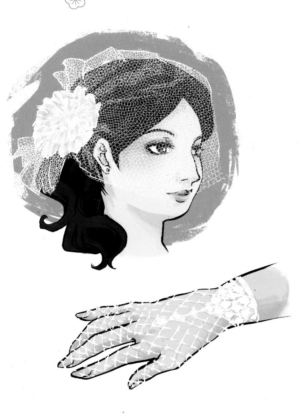

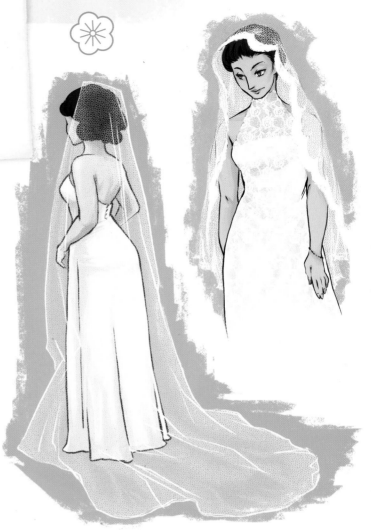

DESIGNING LACE

There are few rules when designing lacy veils and accessories. Long, short, covering the face or not, gathered or left loose—do whatever completes the look.

DRAW A VEIL

1 Crosshatch some lines to achieve rough diamond shapes.

2 Ink the lines a bit unevenly, sometimes lifting your pen entirely off the paper. This will help convey the thinness of the fabric as it catches the light so it doesn't look like you just drew a grid over your character's face.

Hair

Hair styling is an important part of designing the bride. A wedding isn't the time for an everyday 'do. Dress it up a bit with curls, accessories or tiaras.

Formal Shoes

Wedding shoes vary dramatically for style and comfort. Though neutrals are best for men's formal shoes, they don't have to be solid black.

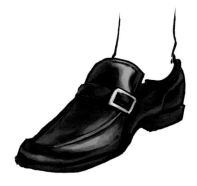

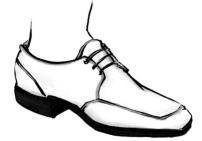

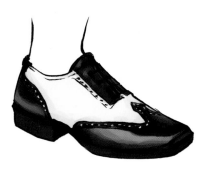

Men's Jackets

You'll find three main types of lapels on jackets. Notched is common on single-breasted jackets such as business suits or blazers. The shawl lapel is usually what you will find on tuxedoes. Peaked is considered the most formal, and can appear on double- or single-breasted jackets.

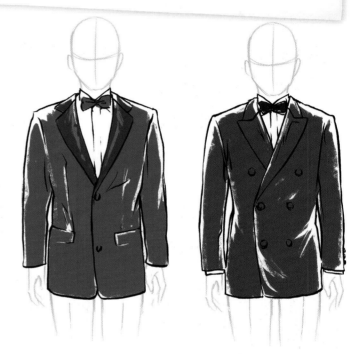

TAILCOATS
The front of a tailcoat cuts away and divides into a long flap of fabric in back.

SINGLE-BREASTED VS. DOUBLE-BREASTED
The single-breasted suit has anywhere from one to four buttons in a single column up the middle of the jacket. The more buttons, the shorter the lapel. Double-breasted suits have two columns of buttons and the sides overlap more, resulting in a much smaller opening showing the shirt.

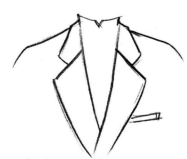

Notched

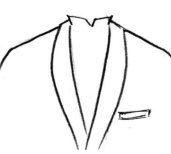

Shawl

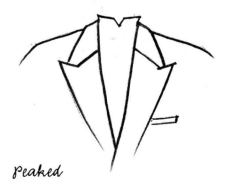

Peaked

Men's Pants

Pants aren't all that complicated, but it's important to know where the seams are and where the pull on the fabric is, or they'll look flat or badly constructed.

Here are a few examples of different pant cuts and how the hem or cuff falls over the shoe.

Practice drawing seaming and folds so you can get them right from any perspective.

DRAW FORMAL PANTS

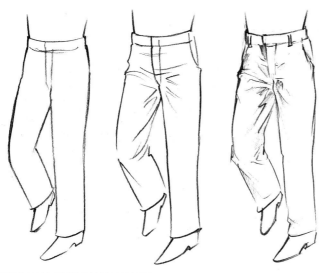

1 Sketch the general outline of the pants.

2 The straight leg won't have many wrinkles, but the bending leg will have some tension between the underside of the knee and the crotch along the inseam. There will also be some pull over the top of the thigh where the bend occurs.

3 Tighten it up. The outer linework should reflect the folds in the cloth. Shading will give it depth, and add details like pockets and belt loops.

Garter Belts and Cummerbunds

The garter belt is an elastic undergarment that goes just over the calf and clips on to socks to hold them up. Though not as common in day-to-day wear, they are still used in men's formal wear.

A cummerbund is a sash worn around the waist usually as part of a tuxedo or staff outfit. They hook or belt in the back and are worn in place of a vest or waistcoat.

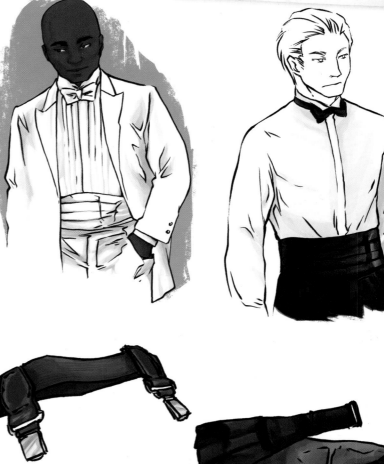

Garter Belts

Cummerbunds

Kids' Formal Wear

Formal wear for kids is really just miniaturized versions of adult clothes. There is just as much opportunity for variety for kids as with adults.

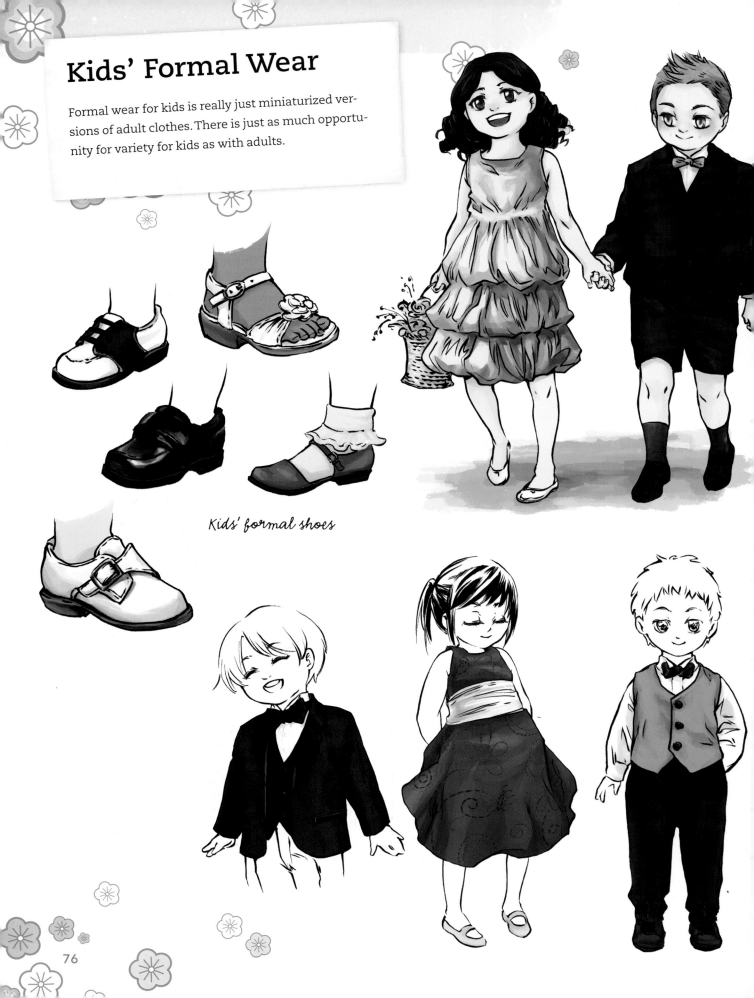

Kids' formal shoes

CHARACTERS
SMALL BOY IN A SUIT

There is a tendency to put kids in cutesy outfits, but there is really no reason they can't dress with as much style and dignity as an adult. This little boy is either an up-and-coming fashionisto, or his mother is training him for good dress-sense early.

1 Sketch the lines of the body and the pose. Remember that kids have shorter limbs and larger heads proportionally.

2 Fill in the widths of the limbs and start adding clothing guides. Little kids tend to be on the chubby side, and the torso isn't well-defined.

3 Define the fit of the clothes and add details like pockets, buttons, creases and folds.

4 Clean up your lines and define the fabric folds.

5 Color it! Kids' formal wear doesn't have to be bright. It can mimic adult, neutral palettes as well.

Non-Traditional Weddings

Bucking tradition can be part of the fun in wedding outfits. Some couples wish to incorporate their personal style in their wedding outfits; others choose to create a regional theme based around a favorite location.

Manderin

Punk

Southwestern

Zombie wedding

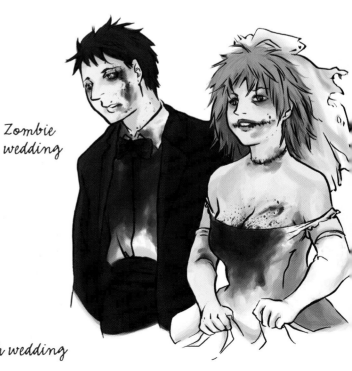

Beach wedding

Bridesmaids and Guests

Weddings are often big deals, so fill out your wedding cast. Along with the traditional bridesmaids, flower girls, best man and ring bearer, don't forget about the families and possibly even extended families.

BRIDESMAIDS

Bridesmaids traditionally wear the same color, often the exact same dress, which tends to be vibrant and sometimes more overwrought than the wedding gown. Give the maidens something nice to wear, or play it up with bows and ruffles so the bride looks that much better by comparison.

OLDER GUESTS

The level of fanciness varies from guest to guest. Older couples are probably not buying new outfits in the latest fashions to go to a wedding. Their standard Sunday best will do.

5 | School Uniforms

School uniforms are meant to be the great equalizers, as they prevent one kid from coming to school in two hundred dollar jeans, while another shows up in something they picked up at the local thrift store. Though uniforms have a reputation as being for upper-class, preppy schools, they are becoming more and more common in public schools. From the perspective of character design, uniforms save you from having to think up a hundred and one different clothing designs for your cast. But that isn't an excuse to slack on the design of the uniform itself, or draw every character wearing exactly the same thing. In this chapter, we'll cover how to design your own school uniform, and then mix it up so your character's personality still shines through.

DESIGNING A SCHOOL UNIFORM

Create a Style Guide

A style guide is a reference of unique details and components of your comic and characters. This could include character markings such as tattoos or piercings, decorations and furniture in a character's house or color schemes of a school's uniforms. Having these things organized and all together saves you time from having to look back through your own comic to reference details you may have forgotten. The following pages are an example of a style guide for a school's colors and uniform components.

1 Pick two base colors for the school's uniform. You can use one or both of the school's colors, or just go with traditional navy blue. It's important to choose one color and one neutral to build your palette around.

2 Select secondary colors to use as accents on the uniform's accessories such as ties, socks, belts and so on. I've picked six colors, three shades of blue and some light and dark khaki tones.

3 Use black and dark gray (as well as white) for standards like shoes, sweaters and shirts, regardless of school colors.

4 Choose colors for plaid. Don't stick entirely to the colors from the first three steps or you will miss out on a great opportunity for variety, but make sure they don't clash either.

CREATING A PLAID PATTERN

Plaid consists of several colors in lines of varying thickness layered perpendicularly over each other. You can generate your own pattern using Photoshop, or you can hand draw a more simplified version as demonstrated in the Tools & Techniques section. For the plaid component of the uniform, I used the secondary colors and added a bit more green to all of them to give them a unique color scheme from a more standard navy blue plaid.

Basic Uniform Components

This is a style guide of all the basic uniform components created in the color schemes determined at the start of the chapter. Think of it like a clothing catalog for your characters' school wardrobe. Blue and gray are the dominant colors, while secondary colors and plaid add variety.

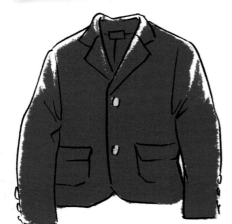

Blazers

Shirts

BOYS' VS. GIRLS' SHIRT COLLARS

Boys' clothing has buttons on his right, and girls' clothing has buttons on her left.

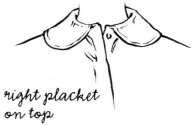

left placket on top

right placket on top

Vests

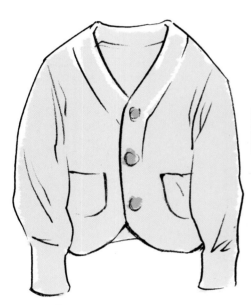
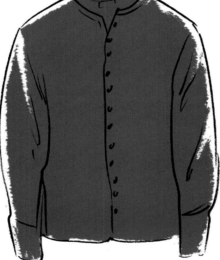

Cardigans

Shorts

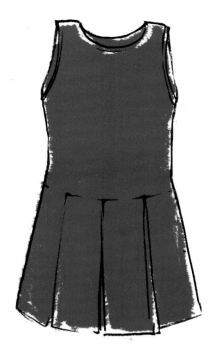
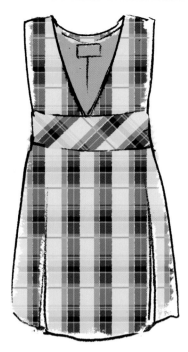
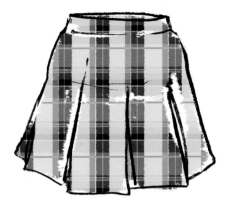

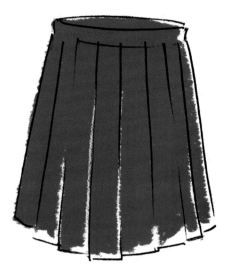

Jumpers

Skirts

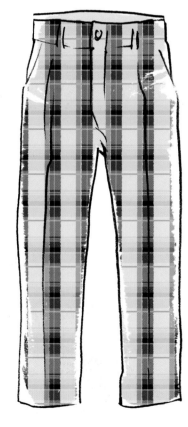

Pants

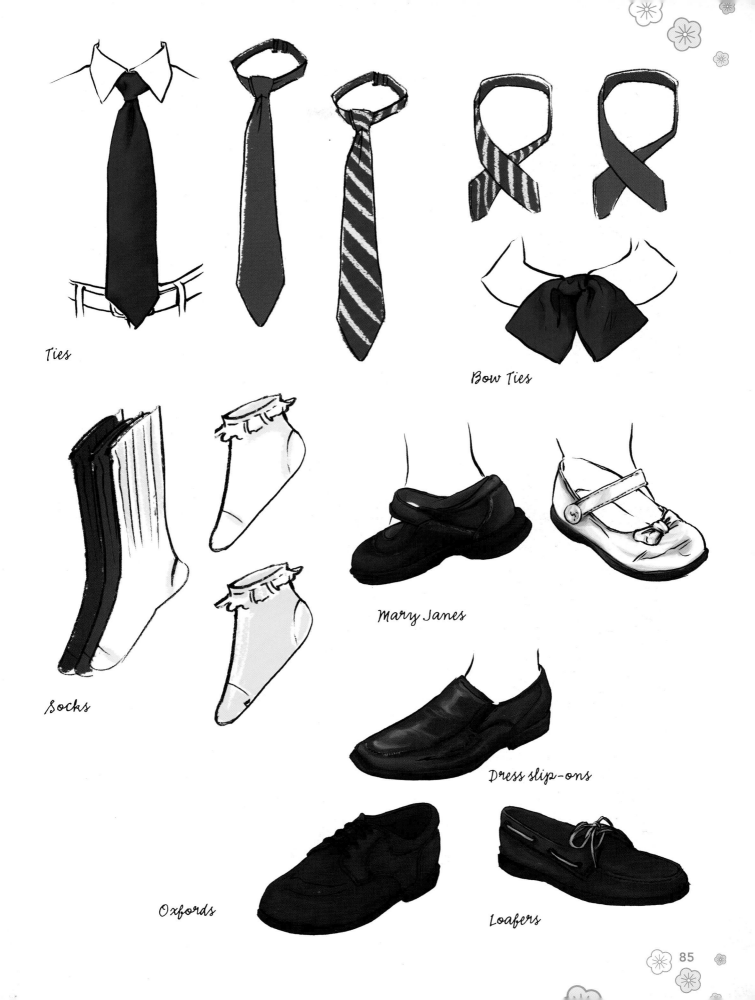

Ties

Bow Ties

Socks

Mary Janes

Dress slip-ons

Oxfords

Loafers

School Crests

Many schools will have some sort of crest, usually in the school's colors and coat of arms. Crests can be simple or extremely ornate. The crest will sometimes appear on the upper left of a sweater or jacket, but also on other school-related paraphernalia.

Crest Shapes

A simple crest like this can be suitable for any kind of school. But one this elaborate suggests an exclusive school.

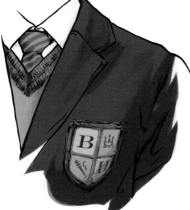

Alter the crest to fit the clothing item or background it sits on. You don't want it to clash!

Skirts

Though it's no longer the norm for female characters to wear skirts as a part of their uniform, there are usually several styles of skirts available.

BASIC SKIRT SHAPE

A basic shape of a skirt is a tube of fabric.

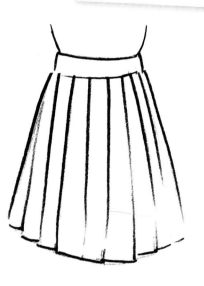

NEAT STRAIGHT FOLD = PLEATS

In a pleated skirt, the fabric folds over itself at the waist in an orderly pattern, creating neat, straight folds down the length of the skirt.

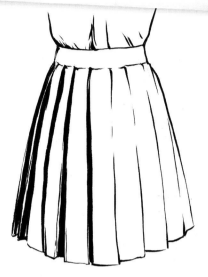

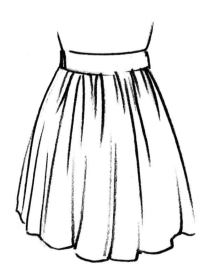

CINCH TO CREATE FOLDS AND RIPPLES

If you cinch at the waist, it creates many folds and ripples. This isn't unattractive, and the skirt will flow more freely than a pleated skirt.

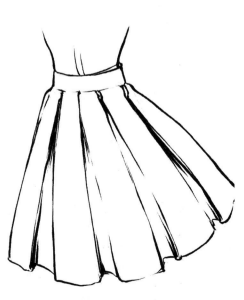

LOOSE PLEATS

The fabric in between pleats that are spread out should be a bit shorter in length so they appear to recede.

JUMPERS

Pleated jumpers are great for younger girls. You can also add decorative buttons at the top of the pleat.

CHARACTERS
PLEATED JUMPER

The jumper, or romper, is a one-piece for girls with a bottom that may be a skirt, shorts or skort (combination skirt and shorts). They are sleeveless and cut off at the knee or above.

1 Start with a basic sketch of the jumper's outline. Flatten out the female figure by drawing a straight cut.

2 Add some details such as a couple of pleats on the skirt to give it some interest.

3 Add some decorative buttons and a few wrinkles around the arms where the fabric stretches. Complete the other drawing details including the undershirt and shoes.

CHARACTERS
PLEATED SKIRT

Pleated skirts aren't a required part of the school uniform, but they are very common and are probably the most iconic wardrobe option, so it's important to get it right.

1 Start with a rough outline, so you know the length of the skirt and the way it's hanging.

2 Sketch in even lines to represent the pleats. They can be as wide or thin as you want them; just make sure to be consistent.

3 The inside folds of the pleat will appear shorter than the outer folds. Keep that in mind as you detail. Rough out the locations of the wrinkles created by the movement.

4 Ink it and clean up your linework, then add some color. The pleats should be clean and fairly wrinkle-free, as that is the point of pleating in the first place. But you'll get some stress wrinkles here and there, particularly toward the top.

89

Seasonal Uniforms

Uniforms change throughout the seasons but retain the same characteristics. In winter, layer your characters' outfits with heavier items like cardigans, blazers and stockings.

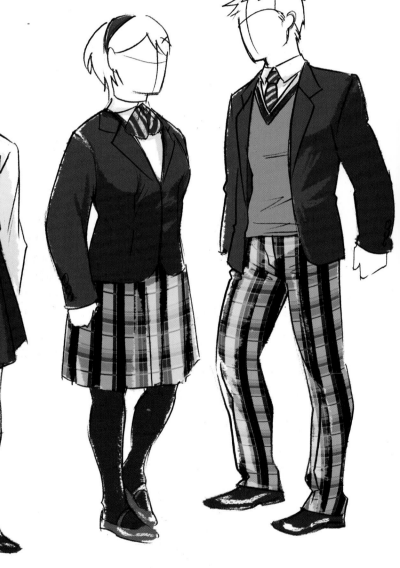

Summer

Winter

Winter Accessories

Most schools won't provide uniform options for absolutely every situation, so personal wear and accessories are usually acceptable for cold weather.

Mix and Match

Even though uniforms are meant to be, well, *uniform*, they can still offer some variety. Allow students to mix and match a dozen or so different pieces to suit their personal preference.

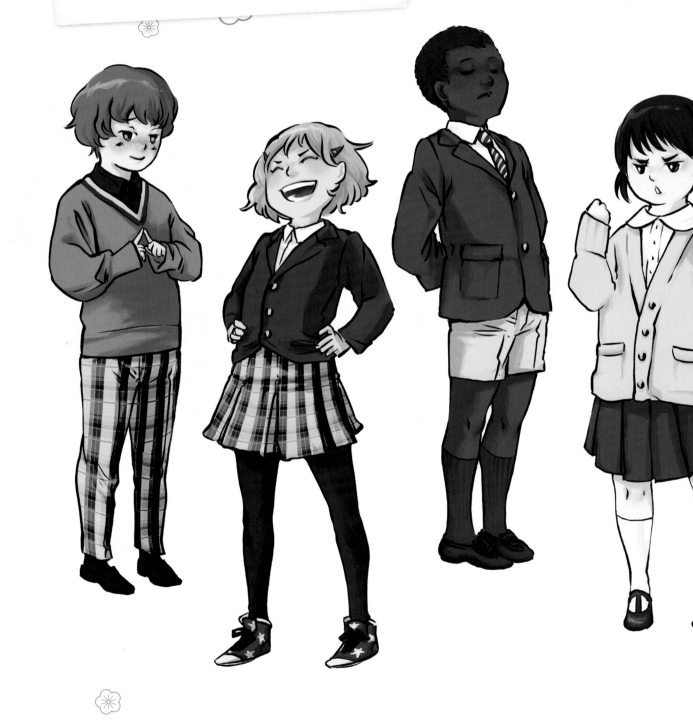

Gym Class

Gym uniforms can be found in public and private schools. They usually consist of a T-shirt, sweatshirt and shorts or sweatpants. Colors tend toward white and one or both of the school colors.

APH

LOMPTON HIGH SCHOOL

LHS

GYM SHOES
Though gym uniforms themselves will be monochrome, shoes can be as colorful or expressive as you want.

Cheer Squad

Cheer uniforms follow the school colors, with additions of white and black as necessary. A dramatic V-shape is common in the design to frame the school name or abbreviation. Short skirts are typical and can be wraps, pleated skirts, skorts or just shorts instead. Your cheer team may even have one uniform for home games and another for away games.

GIRLS' CHEER UNIFORMS

Here are a few examples of different necklines and skirts. When designing your cheer uniforms, be a little more discreet with high school uniforms. More revealing uniforms tend to be for colleges.

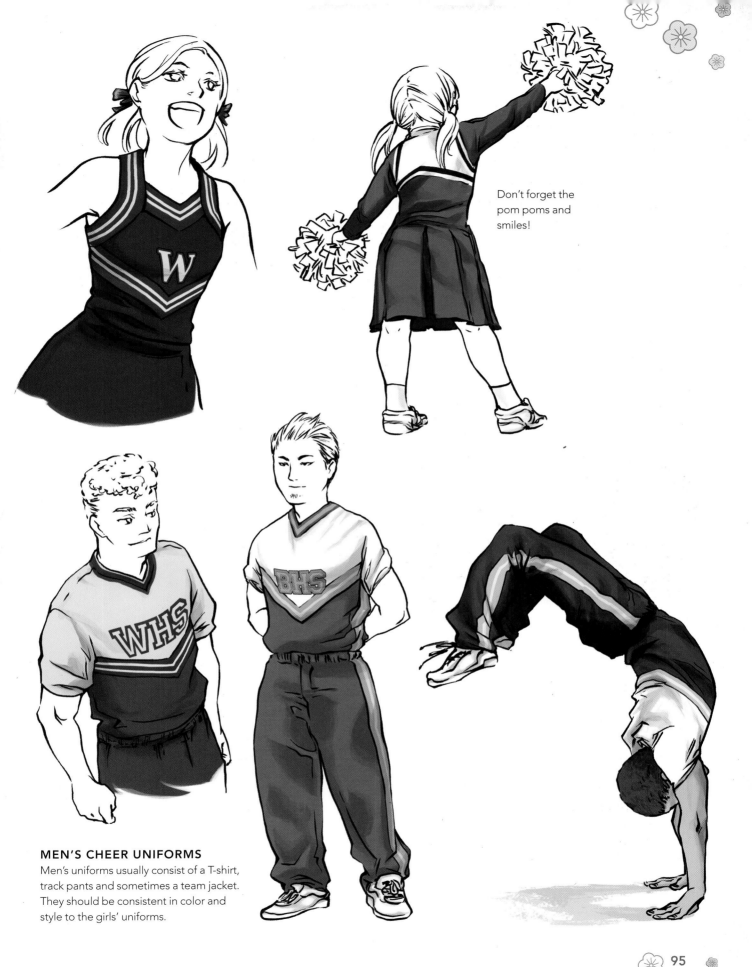

Don't forget the pom poms and smiles!

MEN'S CHEER UNIFORMS

Men's uniforms usually consist of a T-shirt, track pants and sometimes a team jacket. They should be consistent in color and style to the girls' uniforms.

Dynamic Angles

In comics, it's OK to bend the rules to make your poses more interesting. Adding that little extra, possibly illogical, oomph to a character's pose makes it much more exciting.

ONLINE BONUS MATERIAL

Visit impact-books.com/shojo-fashion for a free demo and bonus gallery of sports poses!

EMBELLISH THE ACTION POSE
Bend the angles a little more than would be natural to show the difference between a character who is happy vs. a character who is thrilled.

BENDING OVER
The weight and overall motion shifts downward onto that single foot.

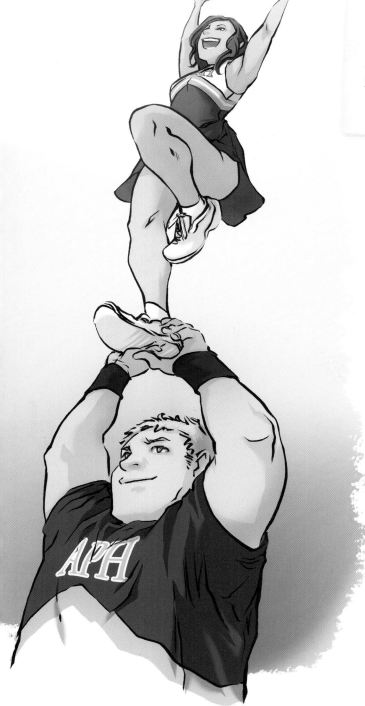

Two-Point Perspective

You can force perspective to create a worm's-eye view that will turn an interesting pose into a dynamic and memorable one. To force perspective in this example, draw the lower parts of her body larger than they should be, so they appear closer in the foreground. Bird's-eye view is when the action is viewed from above instead of below.

straight on *worm's-eye view*

CHARACTERS
BOYS WITH CHARACTER

School uniforms don't have to conform to the dress code. It's your comic, so get creative! Alter uniform designs to show off your characters' personalities and individual style. It's fun to see what they can get away with!

1 Start with the poses. These two have a similar build and are both pretty relaxed, though the one on the left looks a little prim.

2 Sketch in the wardrobe to define the differences in personality. Coifed, styled hair vs. stylishly messy hair. The boy on the left has a trendy scarf, jacket of proper length and skinny jeans. The boy on the right is all about dressing three sizes too large.

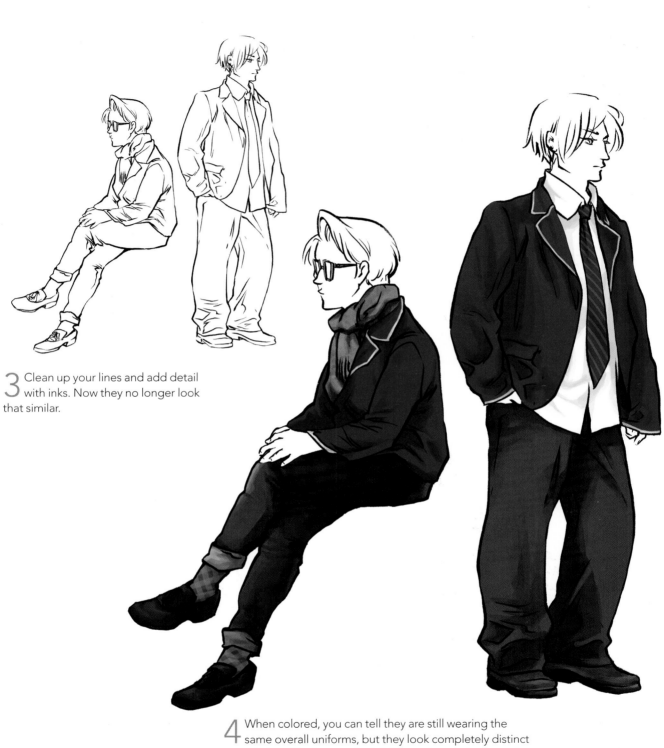

3 Clean up your lines and add detail with inks. Now they no longer look that similar.

4 When colored, you can tell they are still wearing the same overall uniforms, but they look completely distinct nonetheless. The boy on the left likes colors and accessorizing, while the boy on the right doesn't even want to tuck his shirt in.

CHARACTERS
GIRLS WITH CHARACTER

Jewelry, makeup, colorful accessories, hair color and styling are fun ways to stylize your characters. Here we have two girls of similar age with the same uniform components, yet they couldn't be more different. You can really do up your characters so you can barely tell they're in uniform.

1 Sketch the basic line drawings and take note of your characters' differences. Here they are different heights and in different poses to indicate their unique attitudes.

2 Sketch the clothes and add details of the body shapes. Here we have a short, round girl with a timid pose and a tall, slim girl with a more confident pose. You can probably already guess how their clothing styles will differ.

3 Flesh out the details of the outfits— the skirts, blouses, shoes, jackets and accessories. Your characters' differences will be evident now.

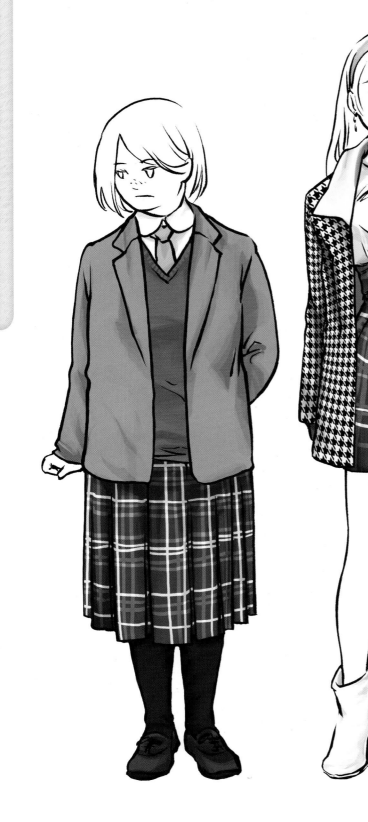

4 Ink and color to complete the looks. The girl on the left sticks to the standard, while the girl on the right exaggerates her personal style with a houndstooth jacket and color-coordinated accessories. The girl on the left looks a little dreary in gray on gray, whereas the high contrast of the houndstooth jacket, white shirt and pink belt worn by the girl on the right really make her pop.

6 | Work Clothes

Employment is a huge part of modern life. No matter what kind of setting your characters are in, anyone who wants to survive on their own is probably bringing in money from one source or another, and jobs are the most common example of that. This chapter focuses only on the more common, modern examples of jobs, from minimum-wage burger flipping to retail to office work, and even the armed forces.

Briefcase and Bags

Businessmen and women need a grown-up solution to the backpack. Here's some ideas for carriers, briefcases, laptop bags and rolling suitcases. As we move into the digital era, briefcases may become less and less necessary when you can get by with just a flash drive.

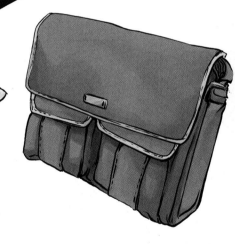

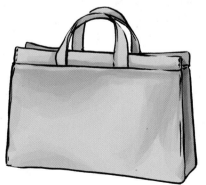

Casual Workplace

The casual workplace may be the true boon of the business world—making money without having to wear high heels or expensive suits. These carefree work environments tend to be most common among the young and artsy, or in a situation where your character runs his own small business.

Casual work clothes can be hoodies and T-shirts or knit sweaters and floral blouses, depending on what is most comfortable for your character.

Some business places require a casual uniform to make it easy for customers to identify employees and to give the business a laid-back vibe. Typically these uniforms consist of a T-shirt in a particular color, a pair of jeans and the shoe of your character's choice.

Technology companies are known for being staffed by young people in casual work attire.

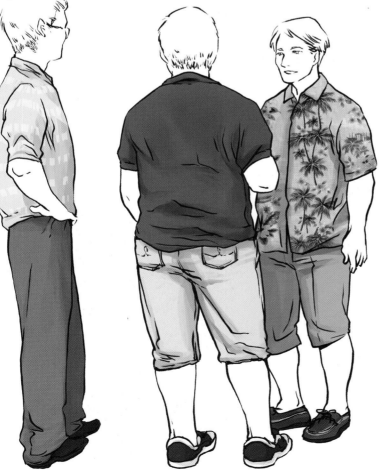

CASUAL FRIDAY

Don't confuse a casual workplace with business casual or even casual Friday, which, in popular culture, requires Hawaiian shirts and khakis.

Belts

Belt design is pretty unlimited. To get ideas for fashionable belts, check out the webpage of your favorite fashion brand. This will give a good idea of what trends are current, and it doesn't take much tweaking to make a design uniquely your own.

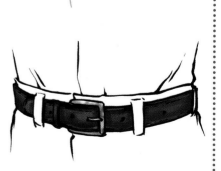

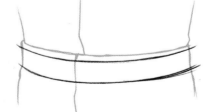

DRAW A BELT

1 Sketch a simple band around the waist.

2 Place the buckle, usually right over the zipper.

3 Design it! Belts can have big and gaudy or funny and interesting buckles, or they can be variations of this classic design.

4 Add the notch holes in the belt, and a few dotted lines for stitching to make it look realistic. Don't forget the belt loops on the pants.

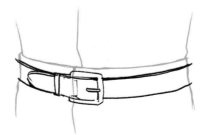

Watches

A watch can be an interesting accessory in an environment where professionalism demands keeping accessorizing to a minimum. Here are some examples of watches that will say something about your character. Remember that watches are typically worn on your character's non-dominant arm.

Classic large men's watch

Dainty, women's watch

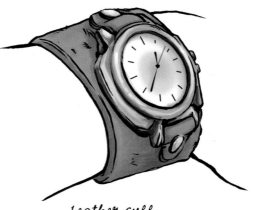

Leather cuff

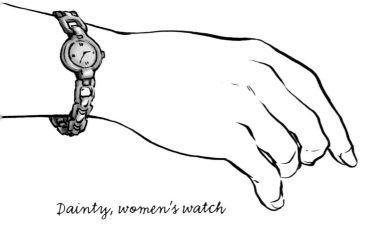

Modern LED digital

Some watches have art in the faces that can range from elegant flowers to cartoon characters.

POSES
SKIRTS IN CHAIRS

When standing up, skirts and dresses are easier to get right than pants, but when sitting, the folds of the skirt bunch and tuck in a tricky way. Here's a quick tutorial of a woman crossing her legs while wearing a skirt.

1 Do a rough sketch of the pose and figure out the proportions. When the limbs are close together like this, it will be more obvious if your proportions are off.

2 Draw the crossed leg, even if you won't see most of it in the finished piece. This will determine how the skirt will lie. Legs cross at the knee, not the thigh, and the crossed leg will appear shorter than the straight one.

3 Do a rough sketch of the clothing and give yourself general guidelines for the folds. When sitting in skirts and dresses, the fabric will tuck under the knees and bottom. There should be a downward dip in the fabric where it goes from the raised leg to the lower leg.

4 Color your character and add shadows in the deep folds of the skirt. Note how the fabric moves from one thigh to another, and how it almost drops straight down off her raised knee, giving the impression that her legs are crossing. Her crossed legs would be noticeable even if her legs and feet were covered by a longer skirt.

Teachers

The clothing teachers wear tends toward business casual, but it's usually the teacher's choice to dress more casual or more businesslike. Gym teachers are usually dressed in sports clothes or in the school colors. You can also include appropriate accessories such as the art teacher's smock or gym teacher's stopwatch.

Student Employment

Students often need to work, too. Teachers will sometimes help prep students for their first job interview, and college students may find work on campus in the library or bookstore.

Interview clothes don't have to be straight-up business attire. The idea is something conservative but still attractive.

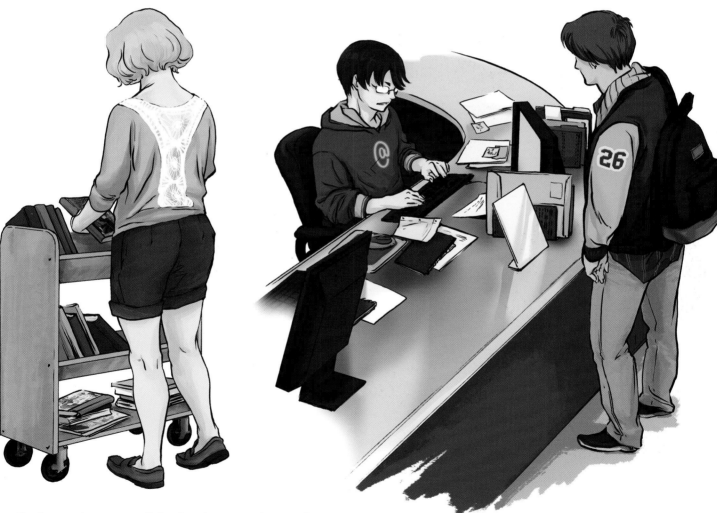

Student employment usually involves the same attire as worn to class. Considering the low wage, minimum hours and lack of benefits, casual dress is one of the perks!

Minimum Wage Jobs

Large chain restaurants usually have a recognizable look or even specific uniforms. It may be a polo with the company logo and khaki slacks, or it can be a bit more costumey. Chances are your character won't enjoy it.

THE POSE DETERMINES THE ATTITUDE

Poses can carry a lot of emotion. We all know the difference between good and bad customer service can be made just by one employee's attitude. In this situation, two workers in the same uniform with the same job deliver entirely different experiences.

DRAW AN APRON

1 Putting an apron on your character is a bit easier if you at least sketch out the clothes underneath first. The apron will follow the lines of the body.

2 Aprons are basically an untailored piece of fabric and they don't lie flat. They will stretch around the waist due to the apron strings and cross the thighs.

Retail Jobs

Retail jobs tend to go for a clean and simple look of neutral pants and a top in one of the company colors. Workers need to be easily identifiable, but in general are allowed to be more comfortable than those in the food service industry.

NEAT VS. SLOPPY

How we put ourselves together says a lot about how we conduct ourselves in a professional environment. It's likely that the boy on the left works harder and is more reliable than the boy on the left.

Unique Uniforms

Some jobs have very unique looks that you won't see anywhere else, and they may not always exactly be uniforms, but simply what you expect to see someone in for that particular line of work.

Bellhop

Pilot

Mail Carrier

DOCTORS AND NURSES

Scrubs are made to be comfortable, cheap and easily washable. They tend to be rather shapeless and aren't meant as a fashion statement. Scrubs in cute patterns or with a personal flair are not uncommon, particularly in private family practices where staying clean is more likely.

Manual Labor

There is more to dirty clothes than just crosshatching over random areas of the body. Safety clothing and equipment usually indicate manual labor and construction jobs. Bright vests, hard hats, gloves, tool belts and heavy boots are good indicators of a character's tough and sometimes dirty line of work. The location and type of dirt or stain can indicate what type of job your character has.

DARK STAINS
Tiny strokes make the dirt look more angular and clumpy, so you get the effect of caked mud. The longer strokes on his coveralls make them look stained and smudged, and it goes all the way to his chest. Whatever he does for a living, it's a messy job.

SCATTERED DIRT
Here the dirt is scattered, with little dots and smudged lines. It looks like he's been spattered, and maybe wiped his gloves off on his coveralls a few times. His gloves are also dirty, suggesting he works with his hands and in the face of things.

KNEE STAINS
This guy's been working on his knees in the dirt, maybe picking weeds or pruning a garden. Draw the dark stains around the knees with layers of wide, short strokes, and the lighter coating of dirt on the front of the boots with lighter, longer strokes.

WORN CLOTHING
Clothes that are worn a lot, particularly for dirty jobs, are going to develop a lot of stains that won't wash out. So even freshly cleaned ones like these still have a lot of discoloration.

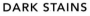

115

CHARACTERS
CAMOUFLAGE

Military uniforms are intended as a visual reminder of unity. Governments all over the world tend to take outfitting their armies very seriously, and if you have to design your own military outfits, you should too.

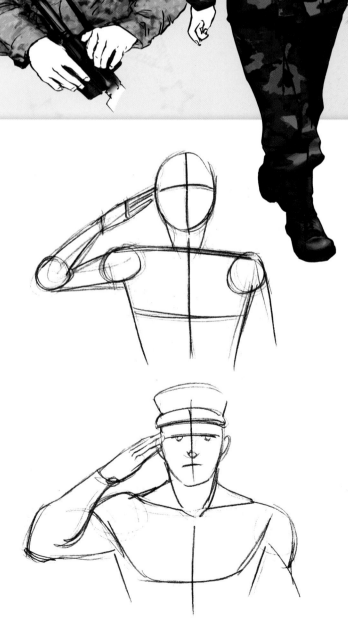

1 Sketch the pose. In this formal armed forces salute, the right hand is raised to where the end of the forefinger touches the edge of the right eyebrow.

2 Roughly sketch the body shapes and the hat. The saluting hand is in the same basic position now slightly touching the headgear.

3 Ink the details. All of the fingers including the thumb should be very straight and together. The rest of the arm down to the elbow should form a straight line, and then the upper arm should be parallel to the ground.

4 Ink the clothes and color the camouflage. Camo is just three or so colors overlaying each other in a blotchy pattern. The colors chosen should reflect the soldier's environment—dark greens for jungles, grays for urban settings, tans for the desert, and so on. They don't all have to be the same hue, though. Probably the most famous camouflage coloring is green, brown and black used for forests.

ONLINE BONUS MATERIAL

Visit impact-books.com/shojo-fashion for a free bonus demo on drawing military characters at work!

7 | Sports

Sports and fashion might not be terms you would usually combine, but nowadays nearly every sport has an iconic look. Whether it's the uniform jerseys of team sports, the skintight bodysuits of speed sports or the heavy padding of contact sports, you can easily determine an athlete's sport by the way she dresses. This chapter discusses the various styles and uses of clothing worn by the players of dozens of different sports.

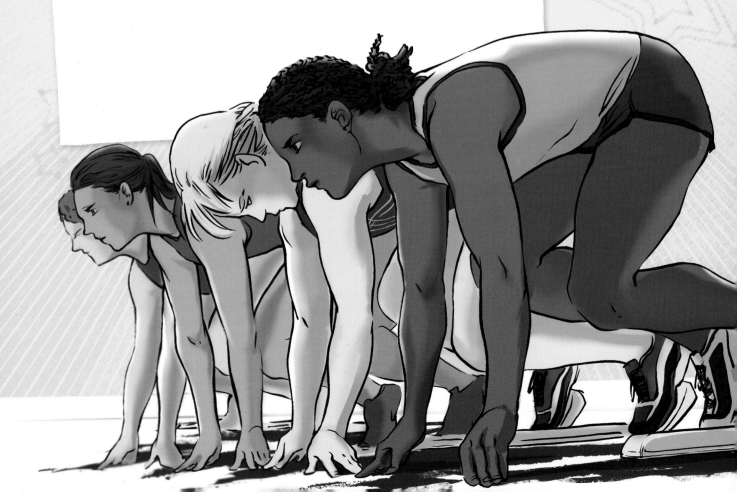

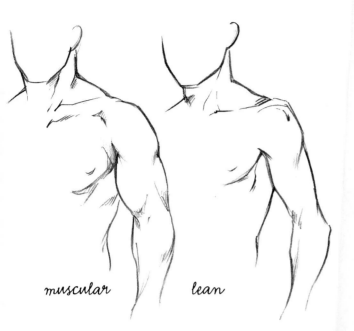

muscular *lean*

Musculature

Defined muscles drastically alter the shape of the body. Including six-pack abs on a character is a popular way to communicate strength in comics and manga. However, having a six-pack is more a sign of an aesthetically good body and low body fat than of actual strength. You can find plenty of sporty people who don't have washboard abs.

That said, just as every character's personality and fashion is unique, the body is unique. There is certainly nothing wrong with wanting your characters to look ripped. After all, your drawings come from your own imagination. Before you choose to draw that six-pack, do your anatomy research. Here's a quick guide to the abdominal muscles.

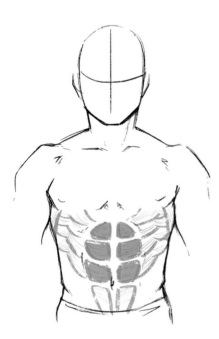

THE SIX-PACK

The term *six-pack* refers to the rectus abdominis muscles (in blue). They end just above the belly button. The muscles below can be defined as well, but aren't part of the six-pack. Keep in mind that everyone's body is unique. While it probably isn't OK to give your character a twelve-pack, it does make perfect sense if the muscles aren't exactly asymmetrical or extend further to either side.

DEFINED ABS ON A MUSCULAR BODY

Use small, light strokes to shade in the edges of muscles, and don't be afraid to let less be more. Hard lines should be used sparingly, as they make the definition in the body look more dramatic. We may call abs chiseled, but it's a bit creepy if they actually look carved into stone.

UNDEFINED ABS ON A LEAN BODY

On skinny frames, particularly with men, you can often see the outline of the rib cage.

An Athletic Build

There is a temptation to describe athletic-looking people as having the same build, but not all athletes are lanky with a six-pack. All athletes have a different distribution of muscle and fat because different sports work different muscles. A bodybuilder figure wouldn't make sense for a marathon runner or a dancer. If you're drawing sports manga, or characters who play a sport, take time to familiarize yourself with what muscles they use the most.

Volleyball

Martial arts

American football

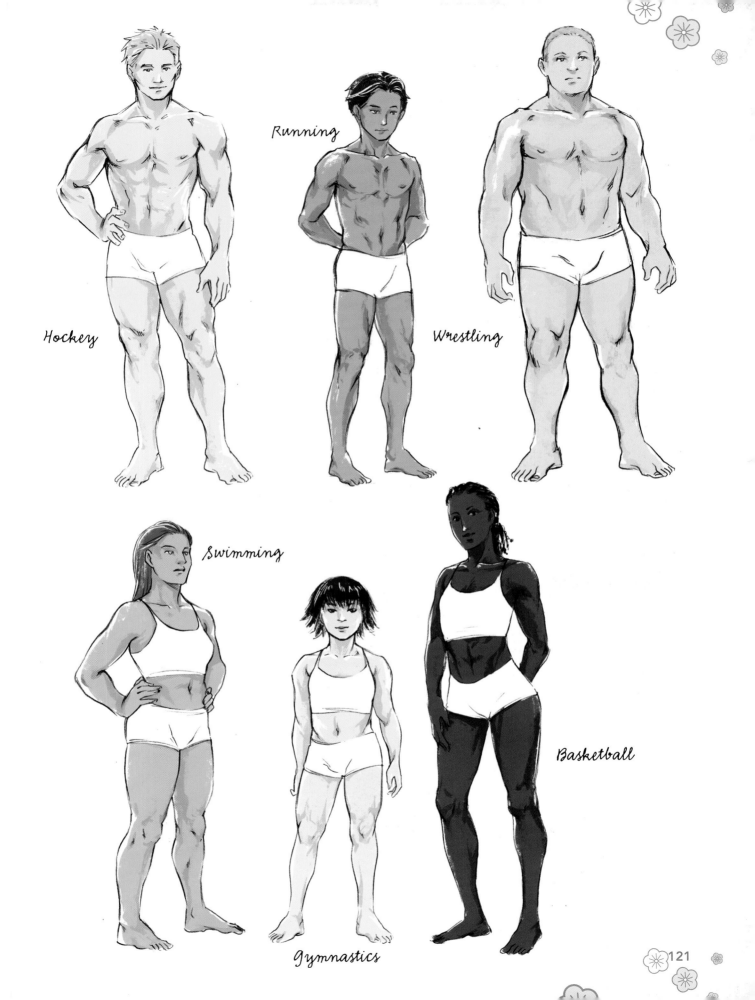

Hockey

Running

Wrestling

Swimming

Gymnastics

Basketball

121

Jerseys and Cleats

Most sportswear is made of light, moisture-wicking fabric (nylon, polyester). This fabric draws perspiration away from the body, and it dries fast, unlike say, cotton, which stays wet and irritates the skin.

A cleat is a protrusion along the bottom of an athletic shoe to help keep athletes from losing their footing. Sports require different types of cleats, so do your research before you draw.

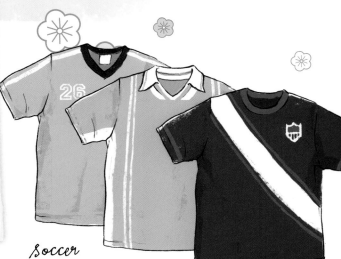

Soccer

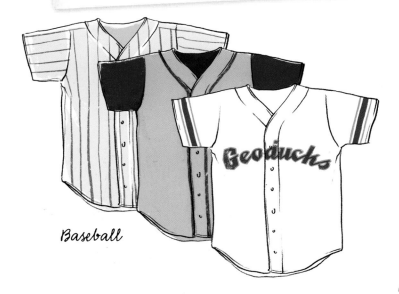

Baseball

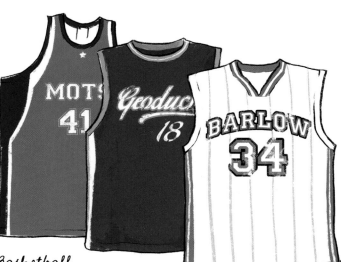

Basketball

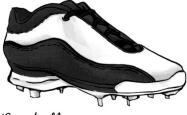

Baseball

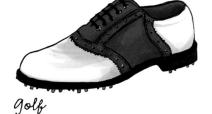

Golf

American football

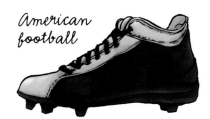

Soccer

Tight Uniforms

Despite being skin-tight, these uniforms aren't designed for their sex appeal. But they do accent the natural lines of the body, and provide a clear silhouette of the athlete. Tight uniforms are about aerodynamics. They do away with unnecessary fabric and instead trim down to where they can hold tight to the body and still protect it from whatever elements the athlete may encounter, be it luge, swimming, gymnastics or ice skating.

Athletes in Action

There are tons of sports out there, and each has its own uniform or at least typical style of dress. Here are some common examples.

ONLINE BONUS MATERIAL

Visit impact-books.com/shojo-fashion for a free bonus gallery of athletic poses and sporting equipment!

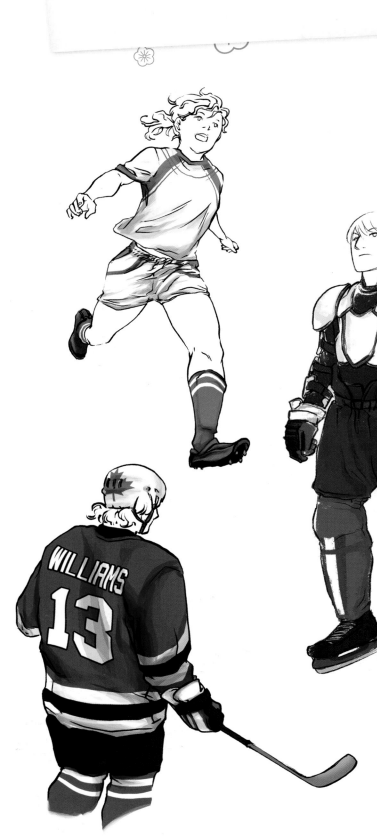

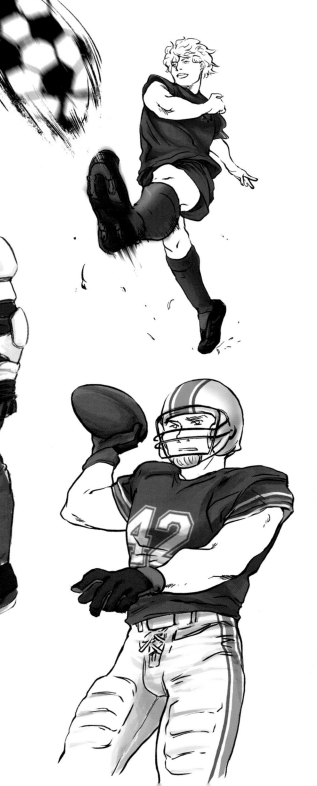

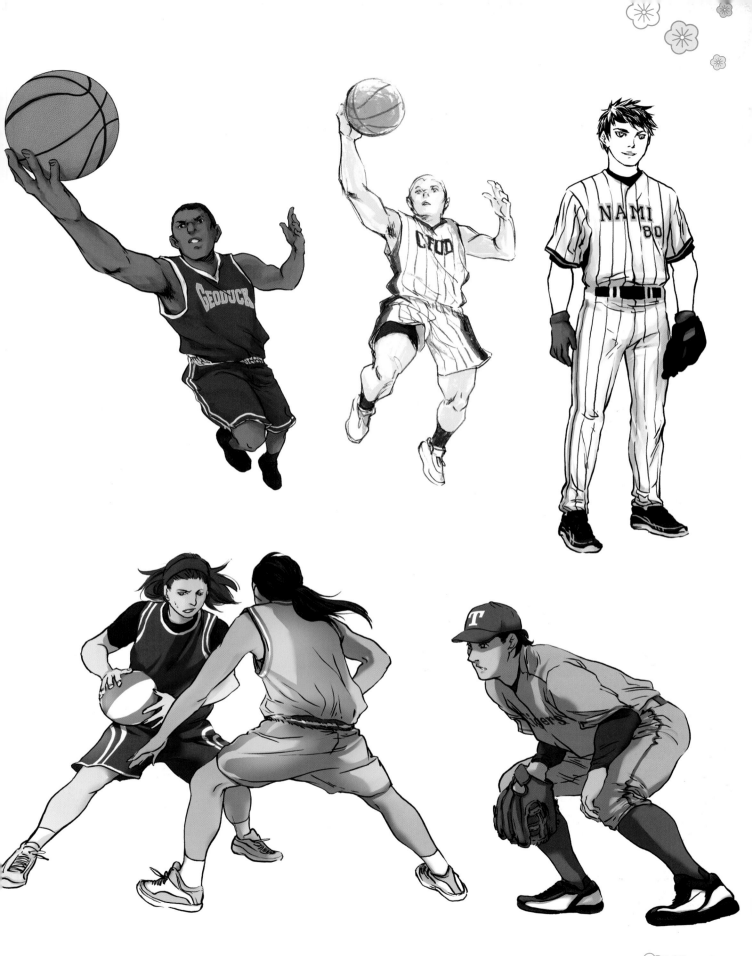

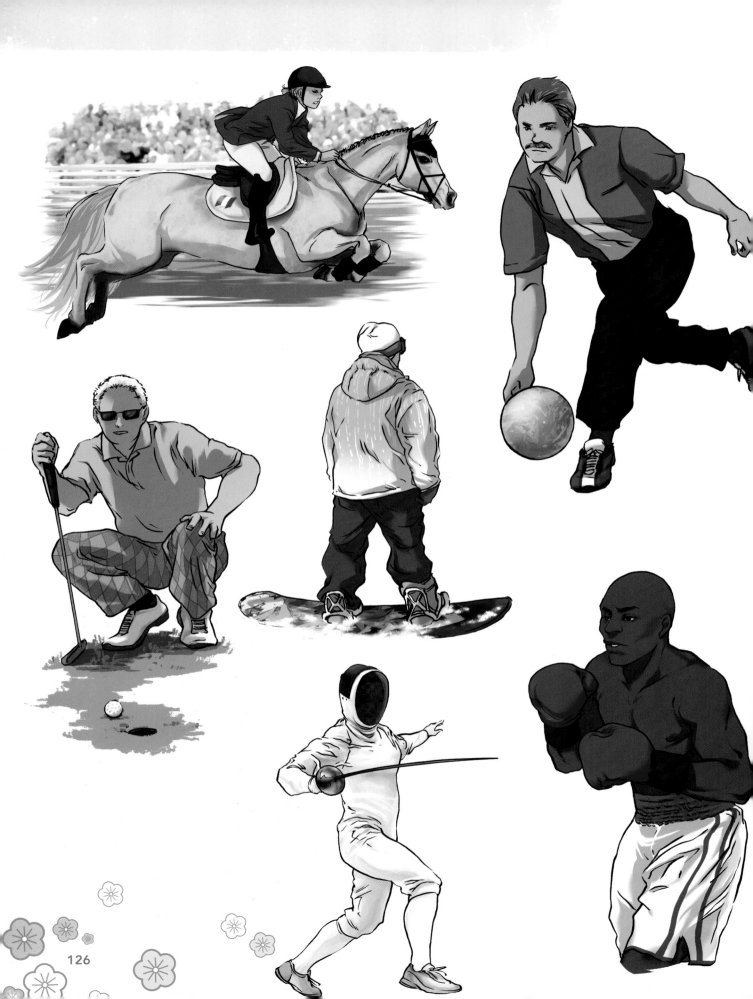

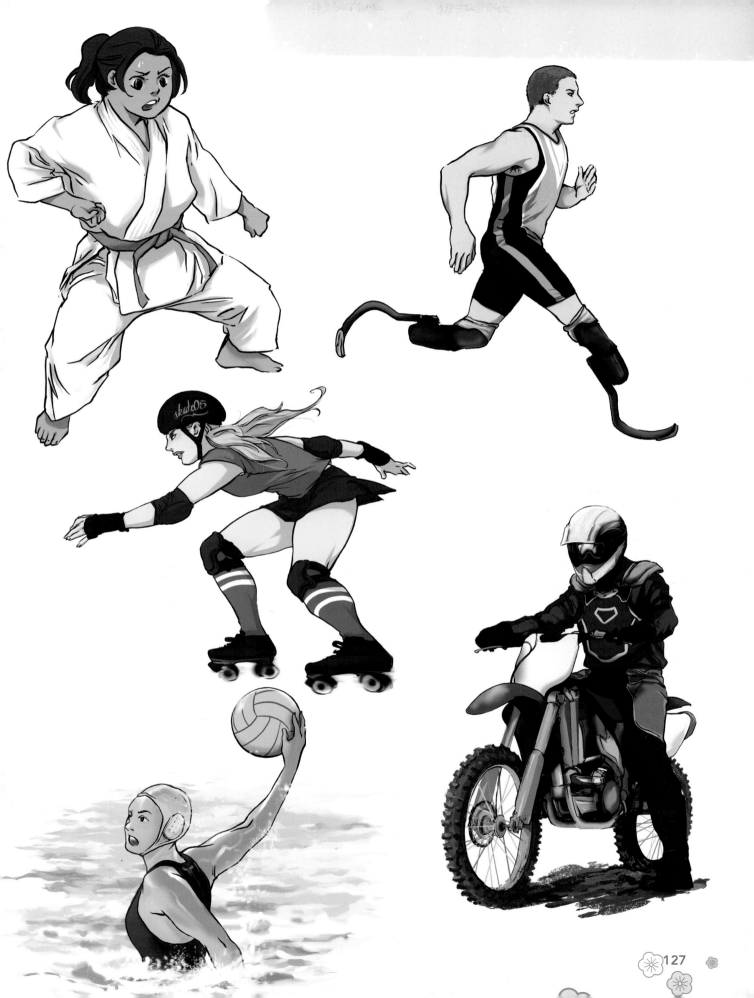

8 | Seasonal

Dress your characters for the seasons! We'll start with spring, which means light and bright colors that reflect the new life popping up all around, and layers to deal with the frequent weather changes. In summer, we bust out bold patterns in saturated colors and high contrast, as well as light fabrics to help survive the heat. For autumn, you can take a lot of your coloring cues from the trees—browns, reds, oranges, yellows and other desaturated earth tones. Your characters will probably need a heavy coat in preparation for winter. Winter coloring is all over the color wheel, but tends toward darker and more saturated. At this time of year, rely on accessories to brighten up outfits because heavy outer clothes can get reused to the point of looking dull.

DRAW RAINDROPS

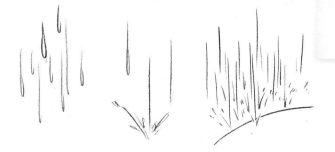

1 Start with a generic teardrop shape. The longer tail conveys a speedy descent.

2 When a raindrop collides with something, it splashes out into multiple drops.

3 To convey the rain from a distance, draw random lines instead of individual drops. The more lines, the heavier the rain! It doesn't have to fall straight down. If there are heavy winds, rain will slant.

Rain

Spring showers can catch everyone unaware once in a while. Here's a brief guide to drawing your characters and their clothes after they've been stuck in the rain.

FRIZZY HAIR
Frizzy hair on a humid day is a nice detail to help convey the season.

DRAW WET HAIR AND CLOTHES

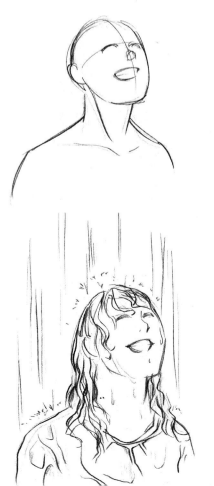
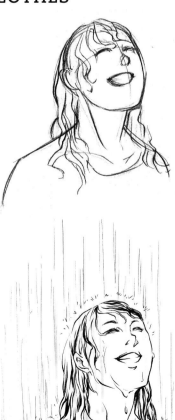

1 Start with the basic head sketch.

2 Normally, you draw the hair a bit away from the head to convey volume, especially if it's curly or wavy. When it's matted down with water, it will stick much closer to the skull and gather into clumps that stick to the skin.

3 Draw the wet clothing creases. Thinner fabrics, when soaked, will stick to the body in clumps as well and the creases between them are more random.

4 For the full effect of soaked hair and clothes, draw a little halo of splashing water around the body and water onto the skin. Water on the face and neck won't flow in straight lines, so take the contours of the face into account.

Spring Looks

Spring is here! Time to bust out the shorts, light dresses and sheer fabrics. Spring colors are warm and bright. To get inspiration for your outfits, imagine the bright colors of spring flowers and new, green foliage.

CHANGING WEATHER

Spring and autumn have a lot of clothing diversity because days can be cool or warm, or both! Wearing stockings, jackets, shrugs or going sleeveless all make perfect sense when the weather can go from chilly to sweltering to cool again.

Open-Toe Shoes

Sandals are popular in the spring and summer and can have plenty of style and flair suitable for going out. Drawing sandals is not much different than drawing regular shoes, you just need to define the foot instead of covering it up.

Swimwear

You can't talk summer fashion without swimwear. Bathing suits come in a massive variety of colors, patterns, shapes and cuts. Designers go out of their way to make the relatively simple concept of comfortable swimwear into an art form of its own. They can be simple, modest, gutsy, bright, ribboned or bedazzled.

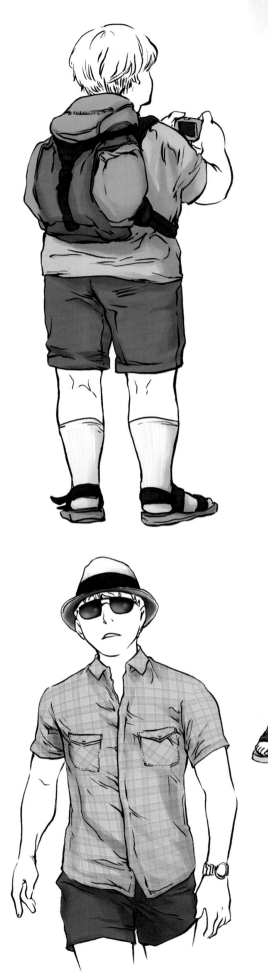

Summer Looks

Summer clothes call for thin, airy fabrics to let a breeze in and light colors to keep cool. Everyone breaks out their shorts and cotton T-shirts to try to beat the heat. Summer is also the time for brighter, bolder looks. Your characters that love attention look great in high contrast patterns and saturated colors.

Sunglasses

Sunglasses are the quintessential summer accessory. They can be brightly colored, wild, weird, fun, sexy, simple or any combination thereof.

Autumn and Winter Looks

Autumn and winter clothing styles often overlap, depending on where your character lives. Up north, autumn can be much colder than winter in the south. People tend to break out their scarves and gloves when the weather turns chilly, and their heavy coats when it turns freezing.

Cold Weather Poses

In addition to a heavy coat, how a character carries himself is a good way to suggest the cold. Is he bent over, arms crossed, head down, shuffling forward or walking with gloved hands pressed to his mouth? Must be pretty cold!

CHILLY WEATHER

Here we have no more than a gently blowing breeze. Enough to stir a few hairs, but not move a heavy scarf. This is pretty typical weather for a chilly day, so the character is OK.

DRAW A WIND-BLOWN CHARACTER

1 The cold causes us to curl up. Sketch out the pose before adding clothing.

2 The coat is pressed close to the body on one side, and blowing away on the other. The scarf and hair are completely in the wind.

3 Because he is bending forward, there are stretch marks across the backs where the fabric is pulling, and another big fold where it is lifting off in the wind. Remember that because clothing is tailored, it can't flap as freely as, say, a scarf. Add some lines in the air for wind and a bit of snow.

Padded Fabric

Puffy outerwear is a popular way to keep warm, and it's cheaper to purchase than thick woolen coats or fur-lined leather. These coats come in any color, but people tend to buy them in neutrals because they wear them almost every day in the winter months.

DRAW A PADDED COAT

1 Sketch the body. Keep the form tight to ward off the cold.

2 Outline the clothing. Note that the big coat makes him look a lot thicker than he is.

3 Clean up the outline. Create wrinkles that pinch around the seams of the padded coat. Add some dark lines to convey depth, but not too thick or the coat will look flat.

4 When colored, the inked seam lines disappear though their shape is still conveyed. The shading is flat and two-toned, because this fabric isn't prone to shine.

DRAW A PADDED SLEEVE

1 Sketch the padded surface of the jacket over the arm. The outline will come up away from the arm. The stretchy, cuff fabric should hug the skin.

2 Draw the stitching lines of the cuff and sleeve.

3 Clean up the outline. Pinch the seams and add a few wrinkles around them.

4 The darker lines in the seams convey the depth of the padded, stuffed fabric. Add a few wrinkles in the middle of each fabric segment but keep the focus on the seams. Long, straight lights with a few straight creases will do for the cuff.

137

Knits

Knit clothing is the perfect look for autumn and winter. They have a lot of visible texture, and often the pattern changes within a single garment.

To draw a knit collar, start with a basic sweater collar and add horizontal curved lines along the neckline.

HERRINGBONE PATTERN

1 Make a vertical line to act as a guide and etch it with V-shapes. You can draw individual Vs or lines that run crosswise and intersect.

2 Repeat the Vs on the knit pattern. You might find it easier to do all the lines going one direction first, and then all of the lines going the other way.

3 Ink the pattern with a brush pen to give the knit pattern more depth.

Apply knit patterns sparsely to a garment just so you get the idea that it's knitted. Here the pattern is applied in the heavy shadows and fabric folds.

VERTICAL KNIT PATTERN

1 Knitting comes in all kinds of patterns, but to create that generic knitted look, make rows of short lines that are slightly curved.

2 Use a brush pen to vary the weight of the strokes, increasing depth and shadow. Create rows of "stitches," keeping the lines fairly uniform.

3 Skip spaces to show the presence of texture without actually filling up the entire garment, which makes it darker and flatter.

The squares of a knit blanket are knitted separately, then linked together so that the different directions of the stitching create a pattern.

A bunch of short lines suggest a tighter weave.

For really sheer fabrics, don't use black outlines. It will make them look heavy and weighed down. Here, brown lines give this torn sweater a nice shabby look.

This big, cozy scarf has just a hint of knitting around the edges. Add shadows to enhance the bulging shapes so the scarf doesn't appear flat.

horizontal curved lines
vertical curved lines
herringbone

COMBINING KNIT PATTERNS

Sketch an outline of the pattern, then fill it with the knit patterns. When coloring, create realistic texture by adding knit patterns in the shadows and highlights.

Index

ABOUT THE AUTHORS

Irene Flores is an illustrator, part-time framer, occasional author and full-time coffee drinker. She is the co-creator of the manga trilogy *Mark of the Succubus* with writer Ashly Raiti published by TOKYOPOP. She has also worked for DC/WildStorm and Marvel Comics, and has been featured in TOKYOPOP's *Rising Stars of Manga* volumes 3 and 5. Irene posts on deviantART under the name **beanclam**.

Growing up in the Philippines, she was heavily influenced by both Japanese animation and American comics. In 1994, Irene and her family moved to the United States, and she currently resides in San Luis Obispo, California. Visit her website at **beanclamchowder.com**.

Krisanne McSpadden was born in Phoenix, Arizona, and has been having vivid fantasies of rain ever since. She is currently working on a BA in psychology, and hopes to use it as a gateway to traveling all around the world and teaching in many countries. Her passions are writing, world design, characters and story, and her preferred medium is manga. This is her first book. Contact Krisanne at **mcspadden.k@gmail.com**.

Shojo Fashion Manga Art School Year 2. Copyright © 2012 by Irene Flores and Krisanne McSpadden. Manufactured in U.S.A. All rights reserved. No part of this book may be reproduced in any form or by any electronic or mechanical means including information storage and retrieval systems without permission in writing from the publisher, except by a reviewer who may quote brief passages in a review. Published by IMPACT Books, an imprint of F+W Media, Inc., 10151 Carver Road #200, Blue Ash, OH 45242. (800) 289-0963. First Edition.

 Other fine IMPACT Books are available from your favorite bookstore, art supply store or online supplier. Visit our website at www.fwmedia.com.

16 15 14 13 5 4

DISTRIBUTED IN CANADA BY FRASER DIRECT
100 Armstrong Avenue
Georgetown, ON, Canada L7G 5S4
Tel: (905) 877-4411

DISTRIBUTED IN THE U.K. AND EUROPE
BY F&W MEDIA INTERNATIONAL
LTD Brunel House, Forde Close, Newton Abbot, TQ12 4PU, UK
Tel: (+44) 1626 323200, Fax: (+44) 1626 323319
Email: enquiries@fwmedia.com

DISTRIBUTED IN AUSTRALIA BY CAPRICORN LINK
P.O. Box 704, S. Windsor NSW, 2756 Australia
Tel: (02) 4577-3555

Edited by Sarah Laichas
Designed by Wendy Dunning
Production coordinated by Mark Griffin

ONLINE BONUS MATERIALS

Visit impact-books.com/shojo-fashion for awesome free bonus instruction, including a demonstration and gallery!

ACKNOWLEDGMENTS

Irene

Krisanne, you still get to have my firstborn child. Or at least a kitten. Once again, this book wouldn't have happened without you. Thank you to my friends and family for their support, motivation and baked goods. And I want to thank coffee for existing.

Krisanne

I don't have any babies to give away, so Irene will have to make do with my undying love. It's only thanks to happenstance and her generosity that have allowed me to work on these books at all. To Box, my BFF, without whom I would have considerably less to say about art. And to my mother, who has always thought better of me than I do myself.

Ideas. Instruction. Inspiration.

These and other fine IMPACT products are available at your local art & craft retailer, bookstore or online supplier. Visit our website at impact-books.com.

Receive FREE downloadable bonus materials when you sign up
for our free newsletter at artistsnetwork.com/newsletter_thanks.

IMPACT-BOOKS.COM

- Connect with your favorite artists
- Get the latest in comic, fantasy and sci-fi art instruction plus great tips, techniques and information
- Be the first to get special deals on the products you need to improve your art

 GET THE LATEST UPDATES, FREE DOWNLOADS AND MORE!

 FOLLOW US!